C000293724

RUNCORN
THROUGH TIME
Roy Gough

First published 2008

Amberley Publishing Plc
Cirencester Road, Chalford,
Stroud, Gloucestershire, GL6 8PE

www.amberley-books.com

© Roy Gough, 2009

The right of Roy Gough to be identified as the Author
of this work has been asserted in accordance with the
Copyrights, Designs and Patents Act 1988.

All rights reserved. No part of this book may be reprinted
or reproduced or utilised in any form or by any electronic,
mechanical or other means, now known or hereafter invented,
including photocopying and recording, or in any information
storage or retrieval system, without the permission in writing
from the Publishers.

British Library Cataloguing in Publication Data.
A catalogue record for this book is available from the British Library.

ISBN 978 1 84868 139 2

Typesetting and Origination by Amberley Publishing
Printed in Great Britain

Introduction

Runcorn has an interesting history going back for over a thousand years and has been well documented. We even had an Anglo Saxon stronghold. The main changes came with the Industrial Revolution in the eighteenth century. The Duke of Bridgewater extended his Bridgewater Canal to Runcorn with Locks down to the River Mersey opening endless opportunities for trade. The sandstone from the local quarries was used in many eminent buildings in this country and abroad. In the nineteenth century heavy industry started to grow with two soap and alkali works, several tanneries and chemical works. The construction of The Manchester Ship Canal, completed in 1894, brought ocean going vessels from all over the world to the docks.

The first permanent crossing of the river Mersey between Runcorn and Widnes, 'The Runcorn Gap', was the railway bridge, a fine looking bridge with wonderful arches on each side of the river followed a few years later by the famous Transporter Bridge which carried vehicles and pedestrians across the river and canal. This means of getting across the water obviously became inadequate for the needs of the twentieth century and a new road bridge had to be constructed.

Large areas of the town had to be destroyed to make way for the numerous roads and bridge supports needed for construction. Many of the rows of terraced houses disappeared quickly, the residents moved to newly built homes on the outskirts of town. The local council did their best to ensure that each community stayed together housing then on the same estate. The new bridge was opened in 1961 and at the same time the old Transporter Bridge sadly ceased operation and was soon demolished.

In 1966 Runcorn was designated a 'New Town' to accommodate the overspill of people from North Merseyside and the changes to the area accelerated at an alarming pace. This was the time when I realised that I would have to take as many photographs as I could of the places I loved before they disappeared. The new shopping centre was built a couple of miles away and a huge number of houses were built on the surrounding farmlands. A revolutionary new rapid transport system, a figure of eight, the Busway, was built which was designed to connect all parts of Runcorn, old and new, quickly and efficiently but it never quite lived up to expectations as more and more families owned cars. Runcorn town centre, with its wide selection of shops selling a huge variety of goods was once the vibrant heart of the community. This changed dramatically when the new shopping centre, now named Halton Lea, was opened. Most of the towns larger shops moved to new premises there leaving just a few, mostly family, businesses to carry on. Nearly forty years on, work to revitalise this part of Runcorn is still going on!

This is a book to show how Runcorn has changed – to evoke fond memories of the past for those old enough to remember and to show the younger generation how the town looked in days gone by.

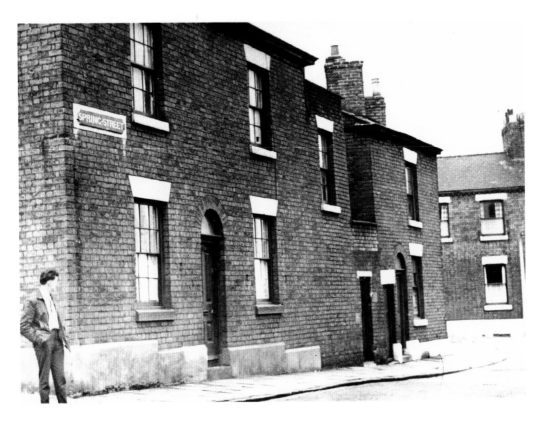

Spring Street

This is a picture of the author standing on the corner of Spring Street, taken about forty years ago. Roy was born in the 1930s in the house, number 8, in the middle of the street. The house was very small consisting of one room downstairs and two tiny bedrooms. It had a coal cellar – the residue of coal dust can be seen on the wall above the grid where the coal was tipped in. The covered entry at the side of the house was used to dry the washing. The whole area was demolished and bright new houses with small gardens and car parking facilities were built on the same site. The street names have been kept, becoming 'Courts' instead of 'Streets'. Spring Street is now Spring Court.

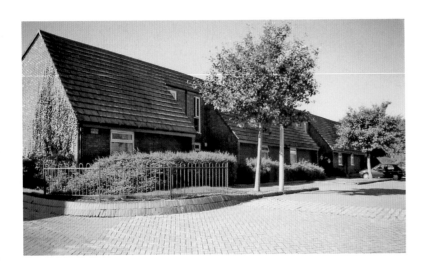

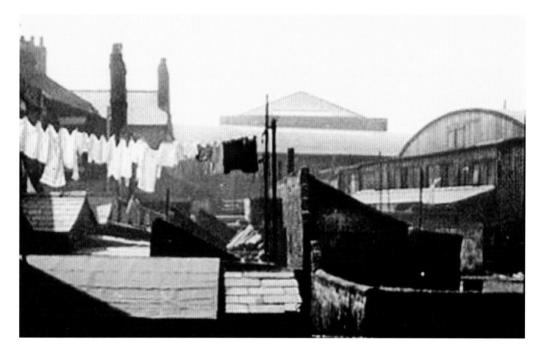

The first photograph the author took

In the summer of 1948, Roy was given his first camera for his birthday, this is the first photograph that he ever took – a view from his bedroom window in Spring Street. Often in his younger years, whilst in the bedroom with the window open, he could hear the BBC radio programme, 'Music While You Work', playing to the workers in the tannery. The washing on the line is in the backyard of a house in Ellesmere Street. It was the house where Norman Brown, a famous Runcorn footballer lived. Beyond the houses and the sheds of Camden Tannery can be seen the roof of Crosville Garage, completed in 1942. The author spent some happy years in the 1960s working as a bus conductor from this garage.

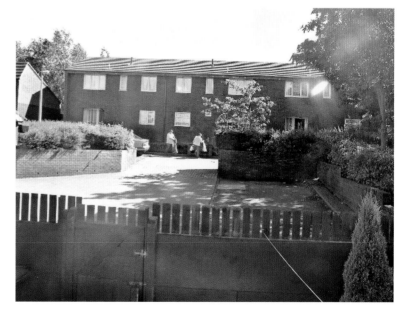

The whole area has been replaced by lovely new properties and this is a photograph from a bedroom window of a house in Spring Court looking towards the place where the tannery was.

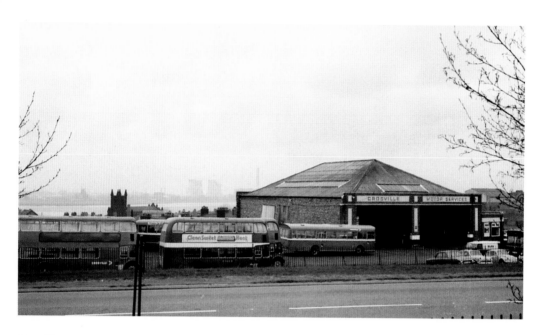

Crosville Depot

Crosville Motor Services moved to this site on Broadway from Baker Road, Weston Point in 1942. The fleet of buses had increased to 29. This became its home for over forty years when it then moved to a new depot at Beechwood, where it still is but is now owned by Arriva. In the 1970s the double-decker buses had already started to be replaced by one-man operated vehicles, one of which can be seen outside the garage. The Spur Road, now the Bridgewater Expressway now runs across the scene with the tower of Holy Trinity Church, the River Mersey and Widnes beyond.

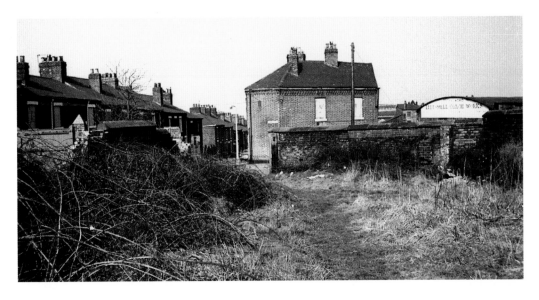

Ellesmere Street from the Baulks

The Baulks was so called because this was the place where baulks of timber were unloaded from barges on the Bridgewater Canal. This timber was used for boat building at the Sprinch Yard. The area became a playground for the local children, they gained access by climbing over the gate. The gate on the left was where the wagon loads of cattle hides were taken into Camden Tannery. The smell of these lorries as they drove up Ellesmere Street to their destination was quite nauseating. Ellesmere Coach Works (formerly W. William's Coach and Lorry Builders) can be seen beyond Caithness Street. Modern homes and paved walks, with trees now stand where there was such a hive of industry.

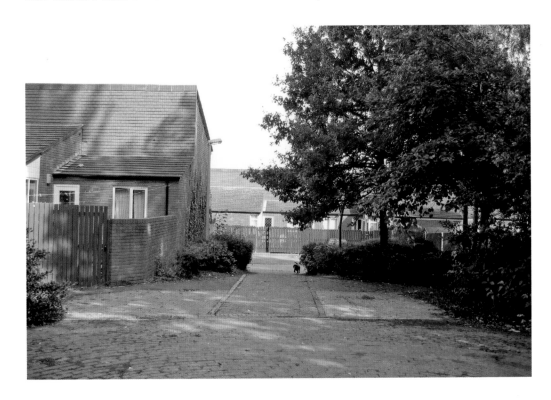

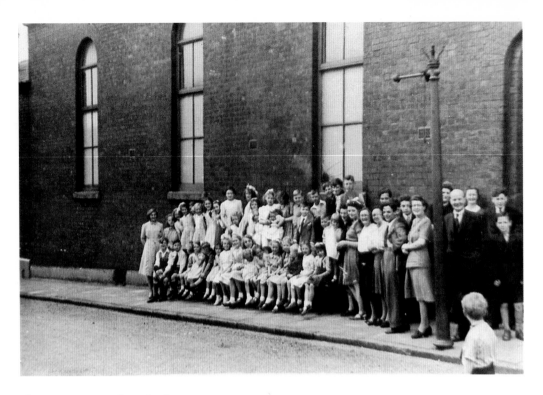

Ellesmere Street Sunday School

Ellesmere Street Methodist Church Sunday school on a Whit Monday in the late 1940s. The children and teachers were gathered outside the schoolroom after the annual 'Whit Walk' and before the tea party and prize giving. The children looked forward to this occasion as this was the day that they wore their new outfits. The children would wonder which book they would receive, would it be the thinnest or the thickest one? These books were treasured by the children as, in some cases, these were the only ones that they owned. The schoolroom was used by the Post Office for extra sorting of mail at Christmas.

The dwellings that stand in the place of the old building are in 'Sutherland Court' retaining the name of 'Sutherland Street' which it once was.

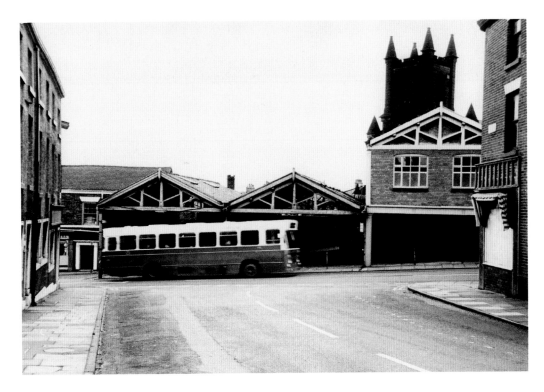

Bottom of Ellesmere Street
A Crosville bus can be seen passing the bottom of Ellesmere Street making its way up Bridge Street. Across the road, behind the bus, is the back of the Public Baths and the canopy of the old market. The biscuit stall, with its large square tins of all kinds of loose biscuits, was situated at the top of the slope next to the swimming baths. The biscuits all had to be weighed and put into paper bags. Many goods could be bought here, clothing, crockery, fabrics, sweets and even day old chicks could be purchased occasionally.

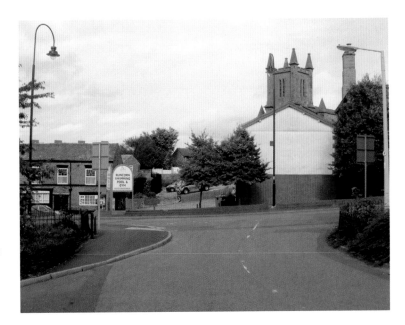

Ellesmere Street was one of the widest streets in the town. The lovely tower of Holy Trinity Church still stands proudly on the horizon.

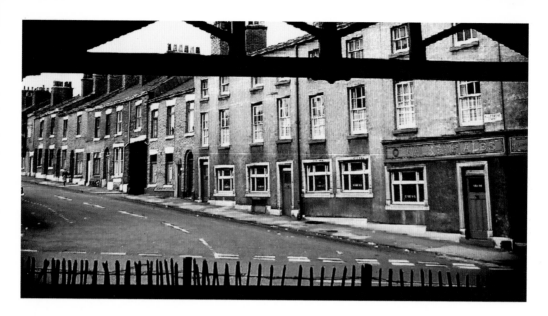

Ellesmere Street from under the Market

The Commercial Hotel, known locally as 'The Glass Barrel' at the bottom of Ellesmere Street. The famous Widnes and international rugby player, Tommy McCue, was once the landlord here. The archway, just higher up than the pub, was 'Barrel Entry', so called because the barrels of beer were rolled down there towards the cellars. Notice the windows of the second house up from this opening – they are different. These windows had to be replaced as the result of an accident. The trailer of a wagon, on its way to Camden Tannery, broke loose, crashed into the house, shedding its load of stinking hides all over the road. The disgusting smell drifted throughout the neighbouring streets. The new housing development is quite attractive.

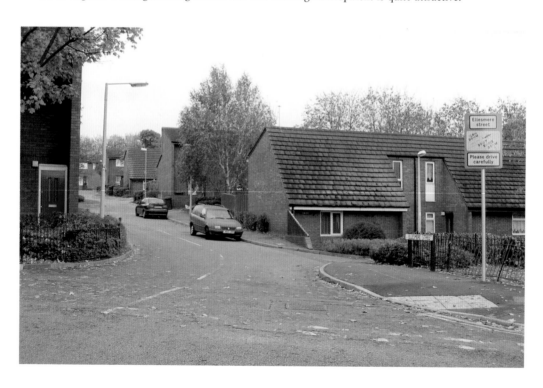

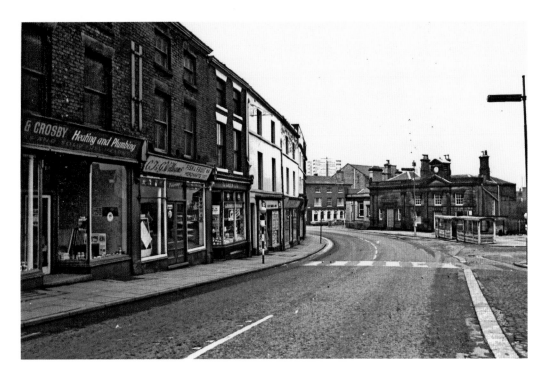

Lower Bridge Street

Joyce and Crosby, a heating and plumbing company with Gladys and Charlie Williams' fruit and vegetable shop next door. Further down, painters and decorators, T. J. Green Ltd. for all your wallpaper and paint. Monks' grocery shop sold many specialist delicacies. Geoff Monks relocated to the new 'Shopping City' but returned to local premises six years later. Stan Lewis, electrical supplies, the shop lower down towards the bend was a well known local cricketer who continued to play for his team well into his seventies.

It is now difficult to imagine just how many shops fitted into this pretty landscaped area. Does this lady crossing the road remember where the 'zebra crossing' used to be?

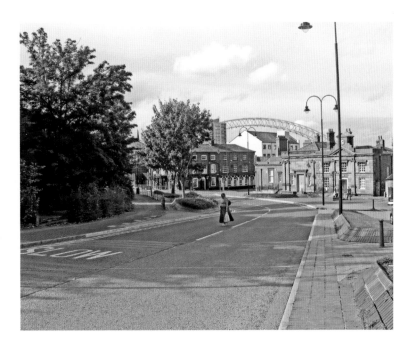

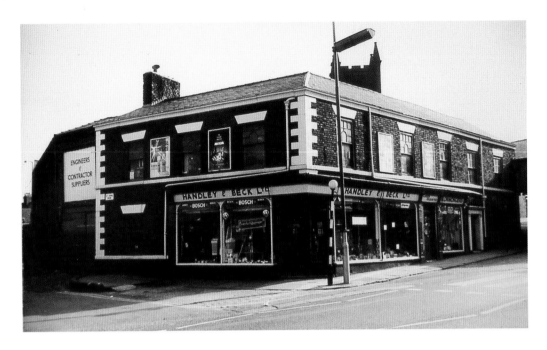

Handley & Beck

Handley & Beck, ironmongers of long standing, traded here for many years. Did you need a 'Wringing and Mangling Machine' to make your laundry day easier? – then this was the shop for you. An incredible variety of stock was always available for DIY tasks. The cobbled area at the side of the premises was for the cart to be loaded and unloaded. They used to deliver Aladdin 'Pink' Paraffin. The stables for the horses were behind the shop. The distinctive windows on this handsome building have, as can be seen in the present day picture, been retained.

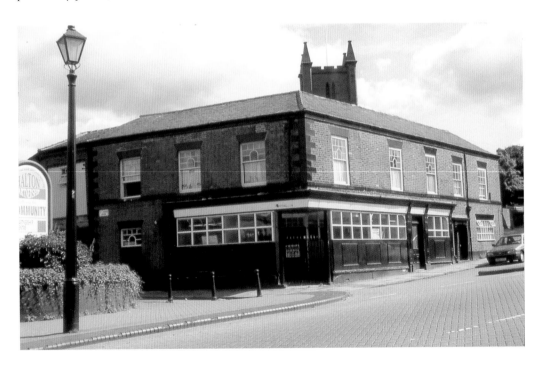

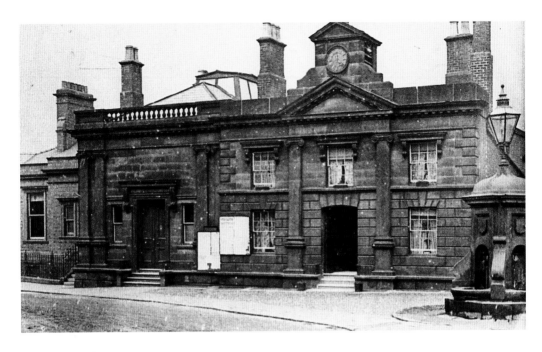

Old Police Station

This beautiful listed building, made of local sandstone in the nineteenth century, was built originally as the Town Hall. In the 1930s the building became the local Police Station and Magistrates Court with living accommodation for the Chief Superintendent above. The stocks have been restored and can be seen in front of the painting of the fountain. The original fountain went a long time ago and a new signpost marks the spot where it used to be. Halton Community Partnership now occupy these premises which have had the many years of grime removed to show the lovely pink sandstone.

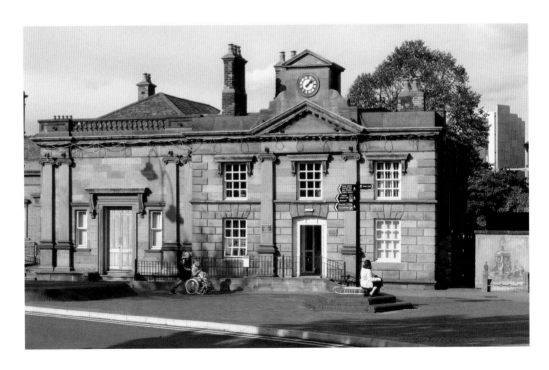

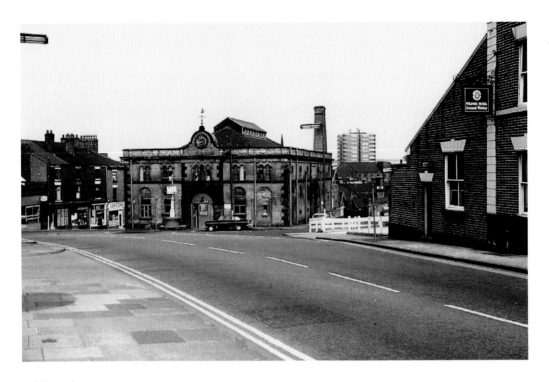

Public Baths

This imposing building was built as a market hall in the 1850s and was later transformed into public swimming baths. Nowadays the pool is open all year round but there was a time when swimming was a summer only pastime. In the winter months the whole of the pool area was covered with wooden flooring and was used for all sorts of activities. Concerts were often held here, parties and dancing, wrestling and boxing matches as well. The radio show 'Have a Go' with Wilfred Pickles and Violet Carson was recorded in this hall.

The cubicles and balconies have been removed and the whole place has been greatly improved. The Wilsons Hotel is on the right.

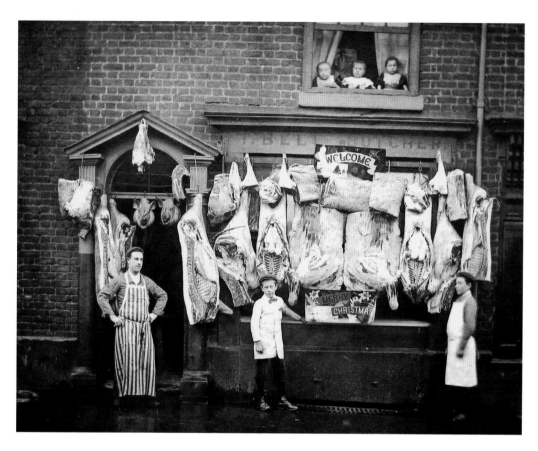

Bells Butchers Shop

Christmas in the early 1900s. Bell's butchers shop in Bridge Street ready for the seasonal trade. A wonderful display of beef, lamb and pork (no turkeys!) with the heads of pigs hanging in the doorway. This establishment was one of about six butchers in Bridge Street alone. There were many more around the town. The staff stand proudly in front of the shop with the children looking on from the upstairs window.

A grassy bank on the side of the Bridgewater Canal is all that remains. The building on the other side of the canal is what is left of Timmins Foundry.

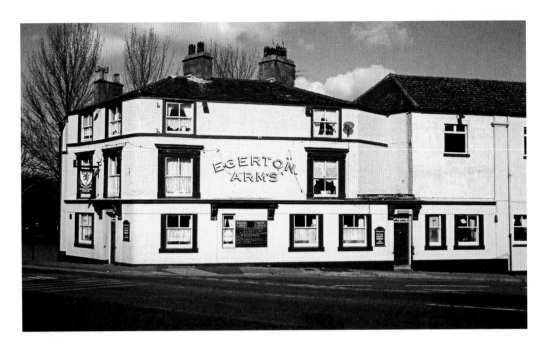

Egerton Arms

The Egerton Arms on the corner of Irwell Lane and Bridge Street, at the bottom of Delph Bridge. This public house was so named because of the connection with Francis Egerton, the Duke of Bridgewater. It was just across the road from the canal and was probably visited by many boat people, throughout the years, as they passed. The new large block of apartments, stretching quite a way down Bridge Street, now dominates the roadside. They were built very quickly after the public house had been pulled down.

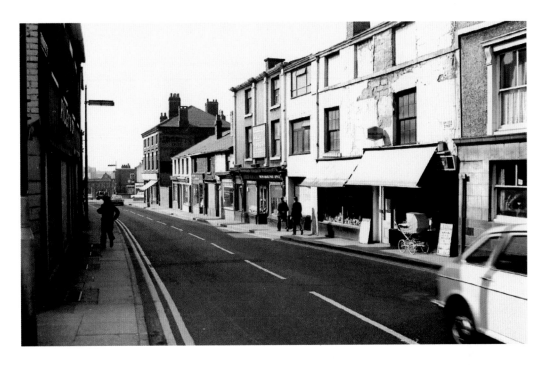

Looking down Bridge Street

Bridge Street, with nearly forty shops, covered almost all peoples shopping needs. Manning's newsagents, Riley's walk around store and Post Office, a chip shop, butchers shops, hairdressers and Littlemore's bakery and many more, lined both sides of the road at a time when mothers could safely leave babies in their prams outside on the pavement. All the individual properties have now gone with the 'Busway' running right across.

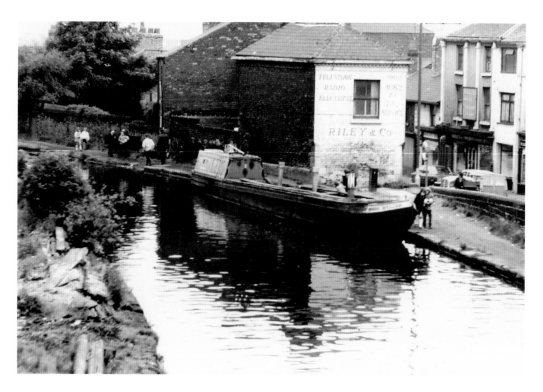

From Delph Bridge

The lovely curve of the Bridgewater Canal from Delph Bridge. The building between the road and the canal was Riley's, a small store that sold so much merchandise. Cycles, radios and electrical goods were in abundance and later, televisions became an important part of their business. The working narrow boat, the *Lamprey* was moored alongside. Johnny Anderson, who lived on the boat, had probably gone on a shopping trip. Timmins and Sons Ironfoundry was on the left. It is now a picturesque scene.

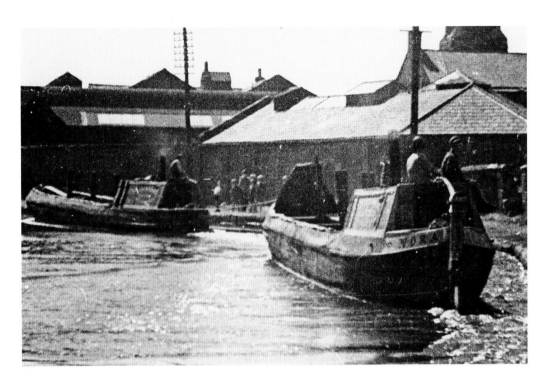

Narrow Boats beyond Delph Bridge

A pair of narrow boats rounding the bend from Delph Bridge passing close to Evans, Lescher and Webb. These boats were heading towards the locks, to descend, and pick up a cargo of materials from the docks for transportation to the Potteries. Crates of crockery could then be brought back. The scene today, more than fifty years later, shows the beautiful autumn colours reflected in the still waters of the canal.

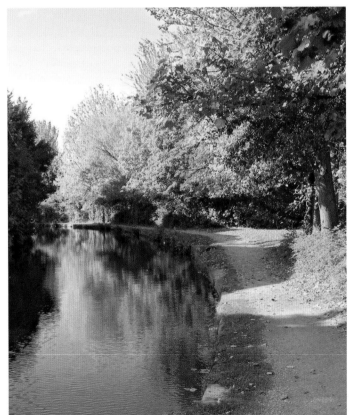

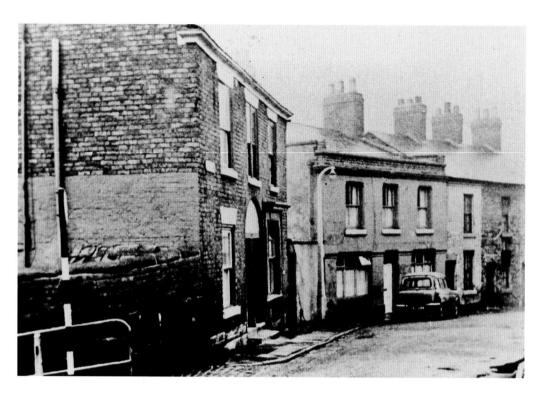

Pool Lane

Pool Lane leading down to Holy Trinity School and Old Quay with a row of very old cottages, some of the oldest properties in Runcorn. Mrs. Langley opened a chip shop between Mr. Millward's house on the corner and what had once been a public house, The George. The top of the steep, cobbled slope on the left is Fountain Brow, which has now been landscaped with steps added, making the pathway down to Bridge Street a lot safer and easier.

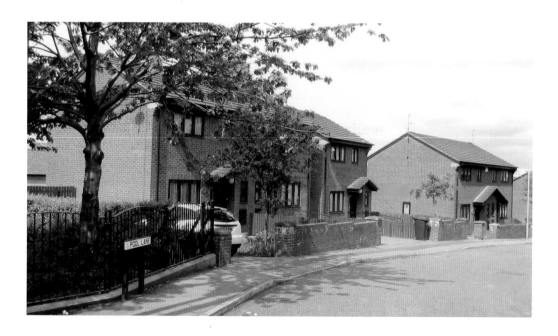

Holy Trinity School

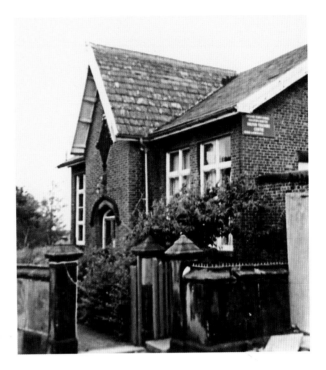

Holy Trinity School, originally built as the Sunday School for Holy Trinity Church, later became a day school which educated children of all ages. It was built on two levels, going 'down the slope' to reach the senior department. The school was very close to the Manchester Ship Canal and was an ideal place for viewing passing ships during playtime and a great temptation for some pupils to follow these ships up the canal instead of going back to classes! The school closed in the late 1960s when it became a Teacher Training Centre for a time. Houses have now replaced the old building.

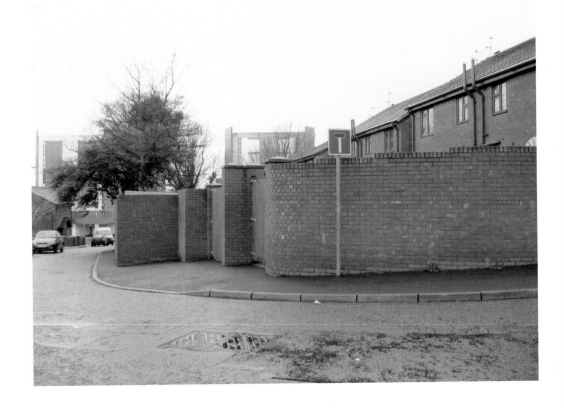

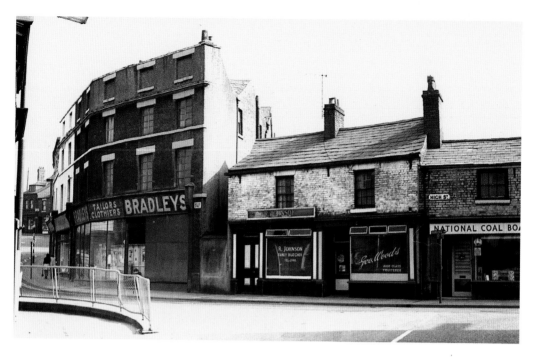

High Street and Bridge Street

Bridge Street to the left and High Street to the right. The two shops in the middle are the butchers shop belonging to Reg Johnson and the fruit and vegetable premises owned by George Woods. Is their address High Street or Bridge Street? Take your pick. Both shops were extremely well known and well supported establishments, they served our town well for many years. Bradleys, on the left, is mostly remembered for the sale of school uniforms for boys, including caps! Now new apartments occupy this once busy shopping area.

A variety of shops in High Street

High Street in the 1950s. Quite a medley of shops which were all demolished to make way for the new block. Top of the row, where the Post Office now stands, was Davies' fancy goods and gift shop which always had a beautiful window display of bright and shiny merchandise. Many of the towns newlyweds were given wedding presents bought from here. Hargreaves sold fruit and vegetables while The Maypole was a grocery shop where most of their goods were not pre-packaged but sold by weight. Who can remember gazing through the window to watch the shop girls moulding the butter with wooden 'butter pats' into an oblong shape? Fletcher's butchers at the bottom later became Dewhurst's, one of a chain of outlets.

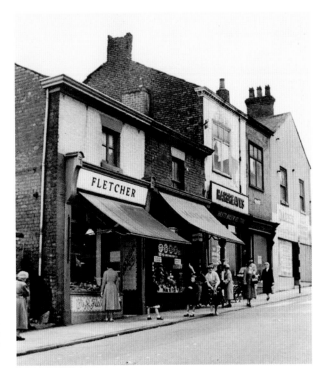

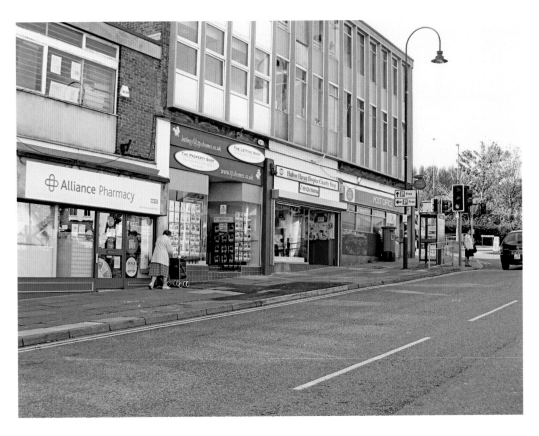

J. H. Harris & Sons

J. H. Harris and Sons, a furniture store of very long standing, on the corner of High Street and Church Street. The whole of this huge block of buildings, offices, café, piggery, and numerous retail shops, belonged to the Runcorn and Widnes Co-operative Society apart from this corner. Although none of the original retailers are still the same, the buildings are still intact housing new businesses. The furniture shop is now a beauty parlour and hairdressers.

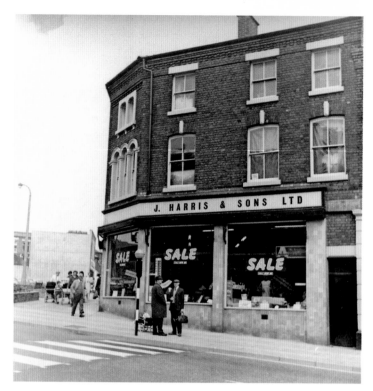

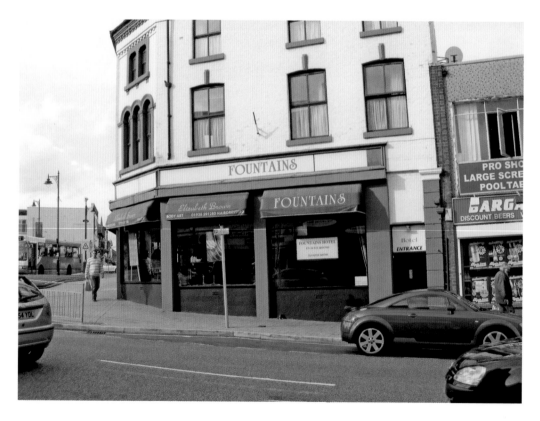

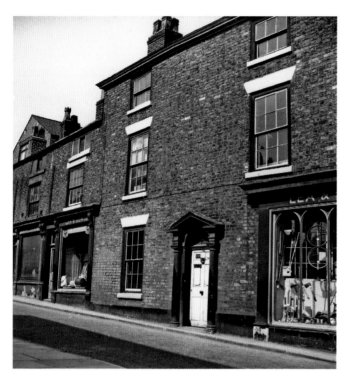

Lea's, High Street

Lea & Sons, ironmongers, in a very prominent position on the top corner of High Street and Church Street. An old establishment founded in the middle of the nineteenth century. They sold a lot of equipment for heating and also produced cylinders of oxygen, hydrogen and nitrogen etc in their works site, just across the road in Nelson Street. These cylinders were supplied to local industries and hospitals. The road was widened and the Halton Direct Link building now dominates the corner alongside the new Bus Station, officially opened in the year 2000. This area is now a very busy road junction.

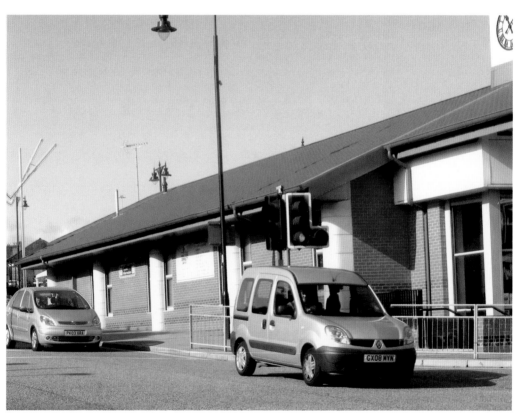

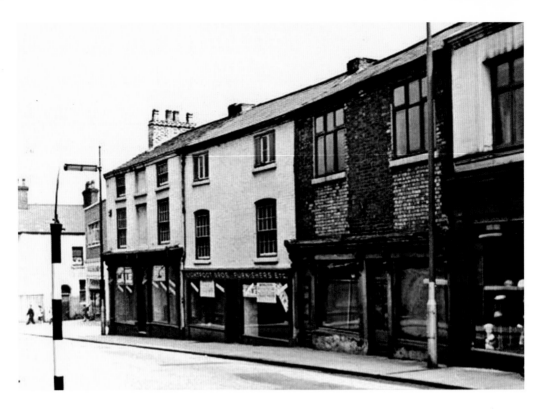

Shops in High Street

Lightfoots shop in High Street sold working clothes for men and boys alongside many other goods. Rolls of linoleum could be purchased here and delivery to your own door was not a problem. A handcart was used to transport any heavy items. The shop was also the local Pawnbrokers. Further up High Street, next door, was Roberts High Class fashion shop. The array of smart hats in the window was a sight to behold. They only occupied one small shop in the late nineteenth century but eventually took over seven premises to cope with the demand in its heyday. An alteration to a dress in 1939 cost two shillings!

A new block of shops, with flats above, have replaced the old ones.

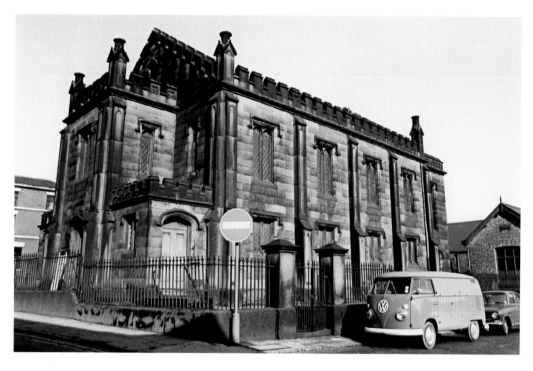

Bethesda Church

Bethesda Church in High Street, between Vicar Street and Alcock Street. This Congregational Church was built in 1835. The church had its own small graveyard and when redevelopment took place, the area had to be very carefully excavated and the recovered remains properly re-buried in Runcorn Cemetery. The schoolroom, which was added later, was used for many activities and, twice a year, by the Runcorn and Widnes Co-operative Society to pay out the half-yearly 'divi'. Members queued with their Black books, which had recorded all their purchases, to receive their cash. Every child had to remember their mothers co-op number when sent on shopping errands. The High Street side of the Bus Station is now on the site and a new Bethesda Church has been built in Palacefields.

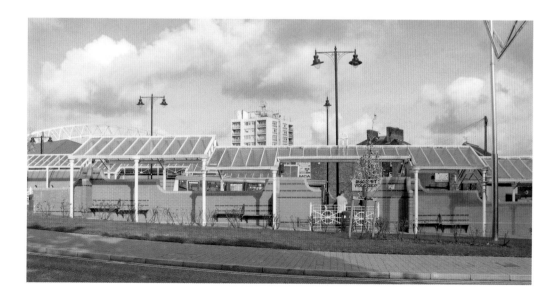

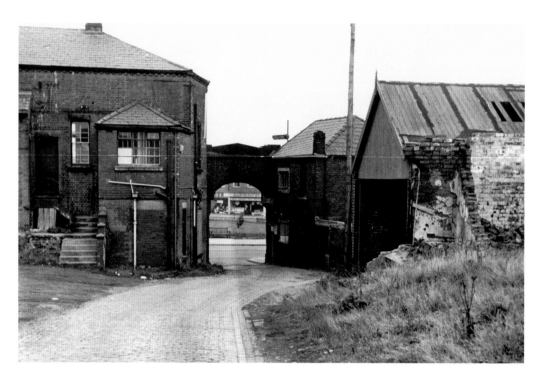

Camden Tannery Gateway

The path leading down to the gateway of Camden Tannery (formerly a soap works) into High Street. The Tannery was closed in the early 1960s. In its busy days, the distinctive sound of clogs, sparking on the cobbles, could be heard as the workers poured through the gate when the siren, or buzzer, sounded at 12 noon, dinner time. They returned a 1 o'clock when the siren blew again. This was always a good time to check your watch. It is now the main, although quite narrow, access road to the car park and The Brindley, our new theatre and arts centre.

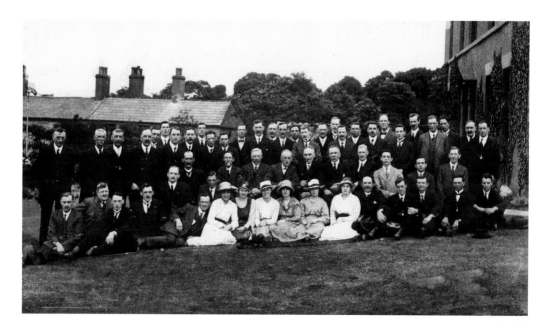

Highfield Choir

The Highfield Male Voice Choir began almost a hundred years ago with just four employees of the Highfield Tanning Company when they formed a male voice quartet. By 1916, the date of the early photograph, the numbers had grown to become a full choir. The tanning industry declined rapidly in the early 1960s, as new modern substitutes for leather were produced, and in 1967, the Highfield Tannery was the last one in Runcorn to be closed. Sadly, there are now no members left who worked in the industry but the choir, with the help of many friends and supporters, sings on. They give many concerts, with talented guest artistes both here in Runcorn and further afield. New members, who enjoy singing, are always welcome. May they long continue to entertain us with their music.

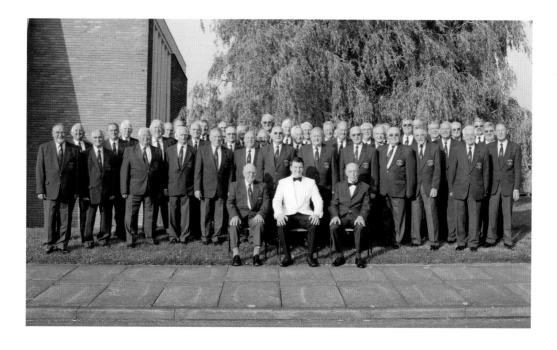

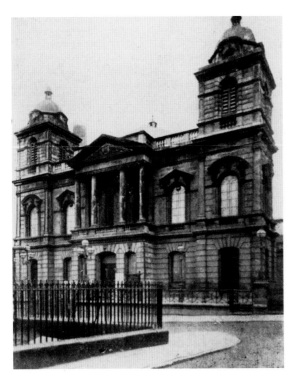

St. Paul's

This imposing structure, St. Paul's Methodist Church dominated High Street. With dwindling congregations it closed its doors in 1964, just short of its centenary and was later demolished. Throughout the years, St. Paul's played a role in the social life of the town with several societies and clubs catering for all ages. It hosted many charity concerts, with eminent guest artistes, in the huge chapel. The busy St. Paul's Health Centre, now on the site, is an important facility in the town. The front wall, railings and steps are all that remains but it seems fitting that the place which once looked after the spiritual needs of the townsfolk now tends to their physical requirements.

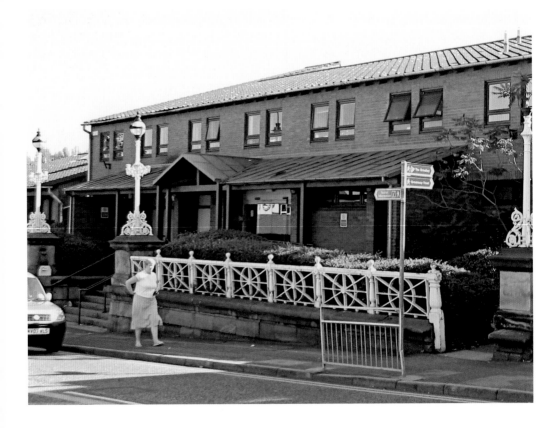

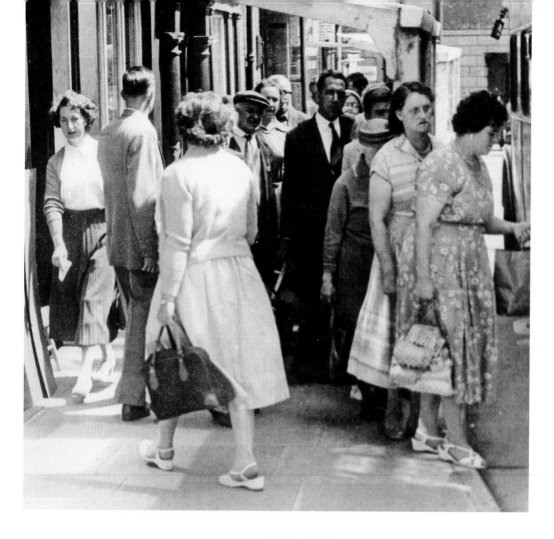

Bus Stop in High Street

In the early 1950s Runcorn did not have a Bus Station. This bus stop, outside Bravermans antique shop in High Street, was typical of many others dotted around the town. The destinations from here were Halton, Moore, Northwich, Sutton Weaver and Warrington. The Braverman family were well known throughout the area. They made Runcorn their home after escaping from Russia in the early part of the twentieth century and became a respected part of the community. The shop is now a listed building and the lay-by is used for parking cars.

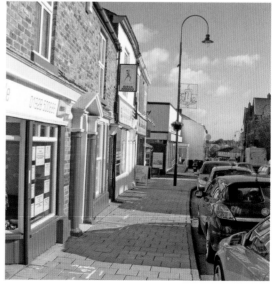

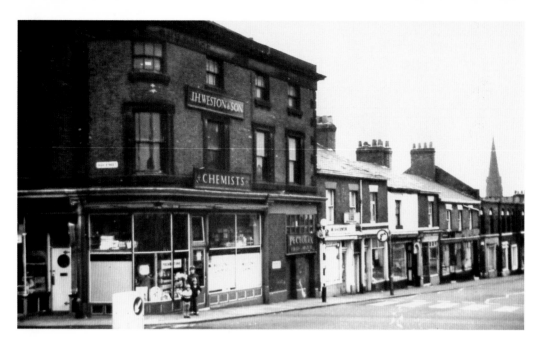

Westons Chemist

The corner of Devonshire Square and High Street where J. H. Weston and Son had their chemist shop. Although the building seems to be rather large, the shop area was quite small. They were famous for 'Pectolix' cough mixture which they prepared themselves. It was advertised as 'The Perfect Cough Cure, Purity Guaranteed'. Lower down was Devonshire Bakery, now in Church Street, famous for irrisistable cream cakes. They had a function room above the shop and many wedding receptions and parties were held there. The road which was once part of the Busway, now runs across the square.

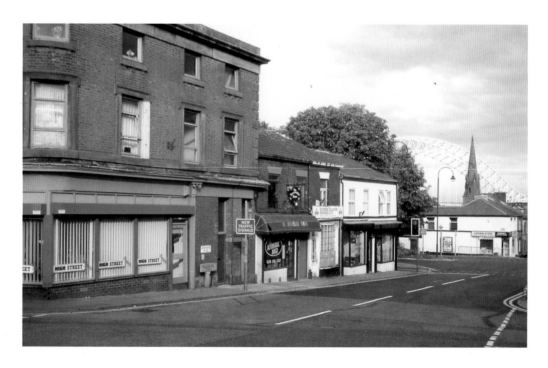

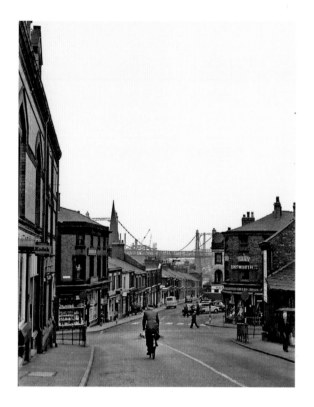

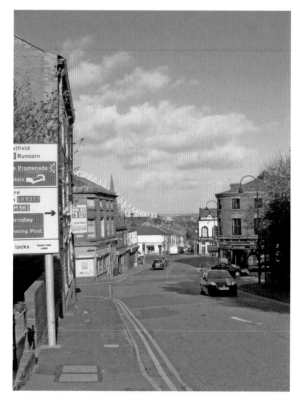

Devonshire Square

Devonshire Place, known as Devonshire Square with the car park right in the centre. This small car park was usually full. The Transporter Bridge can be clearly seen with the cranes in place for construction of the new road bridge. There were many shops in the square. The book shop, owned by Alan Mack was on the right with Coventry's next door selling toys and fancy gifts. The photograph is taken from Doctors Bridge. This bridge is known locally as Savage's Bridge as Savage's butchers shop was located at the bottom corner on the right. The premises on the left was owned by Reg. Chesmore, a well known Runcorn photographer. The road that now travels across the square is now open to all vehicles and is controlled by traffic lights.

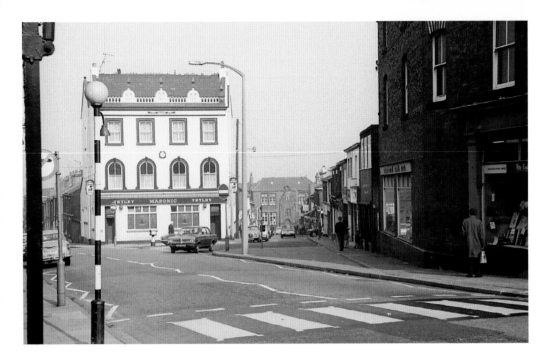

The Masonic

Devonshire Square with Bridgewater Street to the left and Regent Street on the right, both leading down to church Street. The Masonic public house, an impressive looking building with three storeys overlooking the Square. Masonic symbols adorn the façade. This hostelry is commonly known as 'the long pull' and sadly has now been reduced to only two storeys. The alteration was so well done that the change is hardly noticeable. Unsworth's shop, a gents' outfitters, on the right is now occupied by a firm of solicitors.

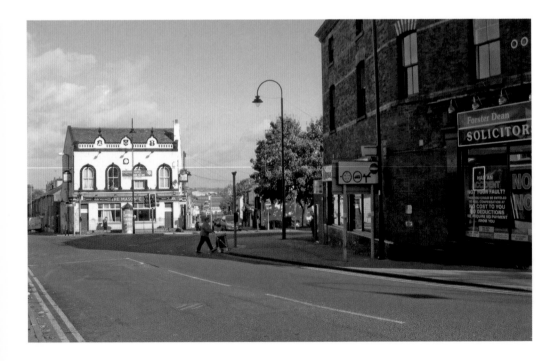

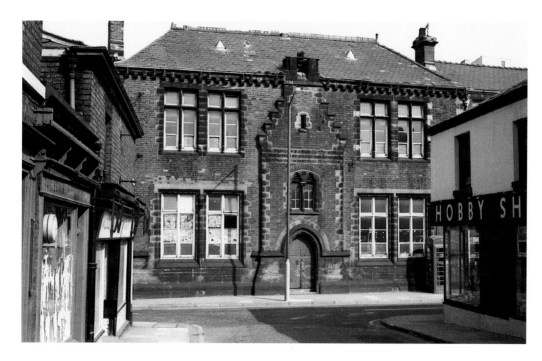

Parish School

This building which stood for well over a hundred years was Runcorn Parish Church of England School which was demolished in 1976 when a new replacement building was built further along Church Street towards All Saints Church. The sandstone carving above the entrance 'Train up a child in the way he should go and when he is old he will not depart from it, Proverbs 22.6' has been preserved and can be seen at the entrance to the new school.

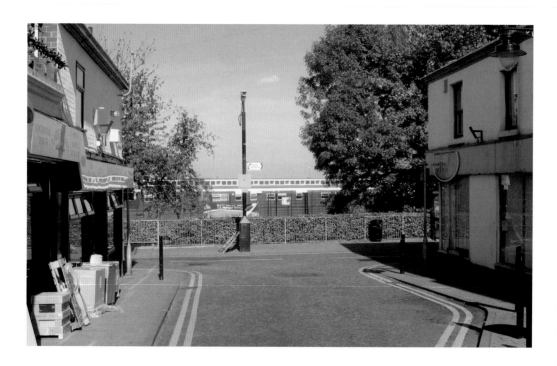

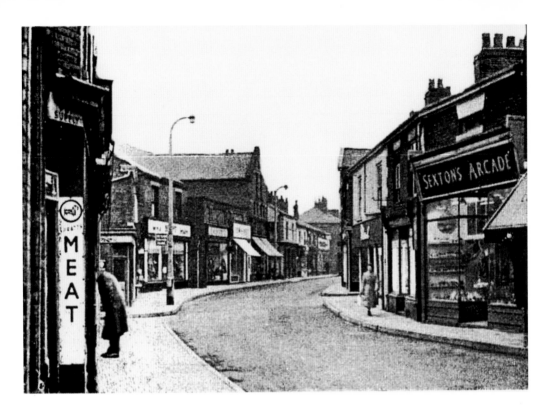

Church Street

Church Street looking towards High Street, with Sexton's Arcade on the right. Is anyone bold enough to admit that they are old enough to remember when it was 'Piper's Penny Bazaar'? Lunt's chemists have now extended their premises into this building. The shops that used to be on the left hand side of the road included Duckett's selling greengrocery and fish, Calvert's for fashions and haberdashery, Irwin's and many more. All these properties went when the road was widened and new shops constructed.

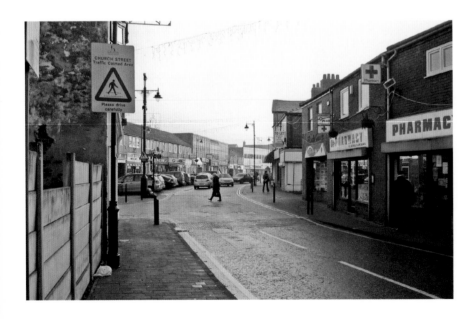

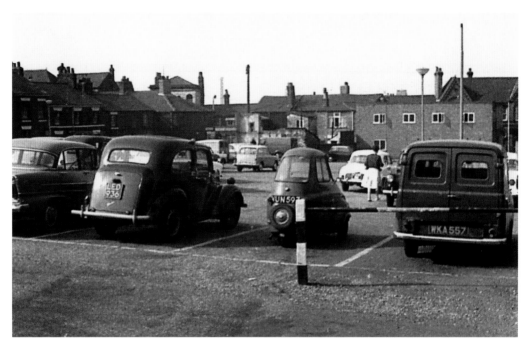

Town Car Park

Runcorn's first paying car park was between Princes Street and Granville Street with a fine collection of vehicles of the day. The bubble car in the centre, if it still exists, could now be quite valuable as a collector's item! We still have a car park here (now free). Churchill Mansions, a block of high-rise flats can now be seen in the distance.

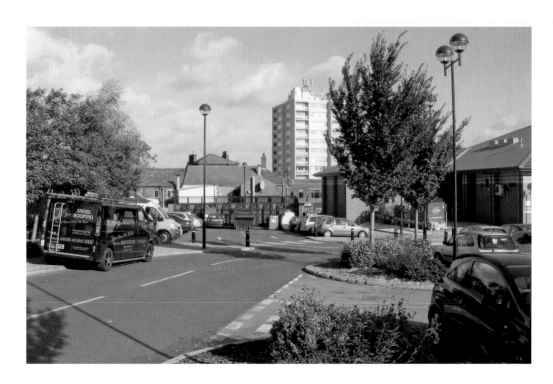

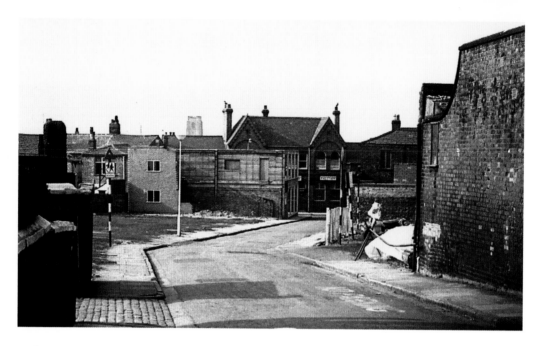

Loch Steet

Loch Street was one of the streets that connected High Street to Church Street where there were once more than forty, small, Victorian terraced houses. The cobbled entrance on the left, was where Ackerley's Coal Merchants plied their trade. Fuel was often scarce and youngsters would be sent to the yard to buy a small sack of coal when stocks were available. Mr. Ackerley would kindly lend them one of his sack trucks to carry the coal home. This was a tricky operation when kerbs had to be negotiated, the sacks fell off! A supermarket and car park are there now.

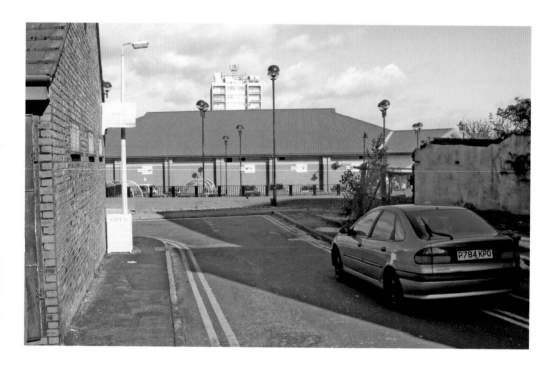

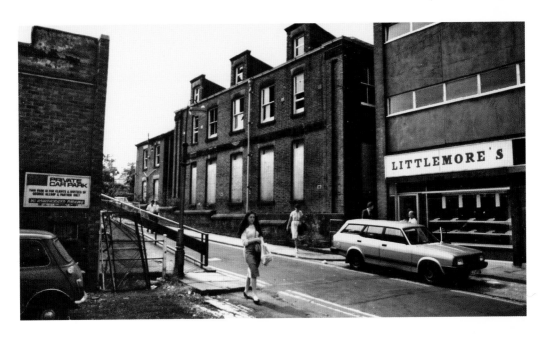

Granville Street School

Granville Street School before it was taken down and replaced with a supermarket. Lower down the street, Maurice Littlemore can be seen standing in the doorway of his shop, chatting to passers by. Maurice and his family had been bakers since 1915 when his uncle Joseph, joined later by his father, Frank, started the business in Union Street. They moved premises several times to Bridge Street, Greenway Road and Church Street until finally, as we see here, in Granville Street. Everyone can remember the delicious 'meat and potato pies' for which they were famous. When Maurice retired, the shop was closed and lay empty for a while but is now occupied by Richard Monks, from another well known family of traders. It is now a well stocked delicatessen. The old market and shops on the left have now been rebuilt

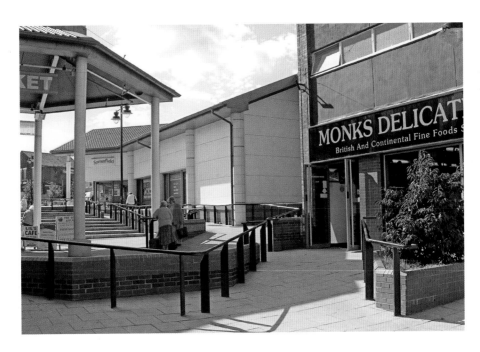

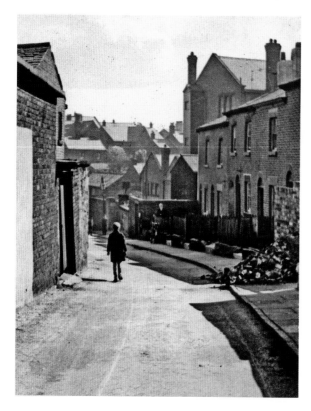

Water Street

Water Street was between Brunswick Street and Mersey Road. There was a row of small cottages on the right hand side with the large Runcorn and Widnes Co-operative Society bakery beyond, well known for the crusty fresh bread produced, and delivered daily. These premises are now used as a Kwik-Fit garage. The buildings to the left of the street were derelict for many years apart from the one at the bottom which was used as a warehouse for furniture and antiques by Mr. Collins, a local auctioneer.

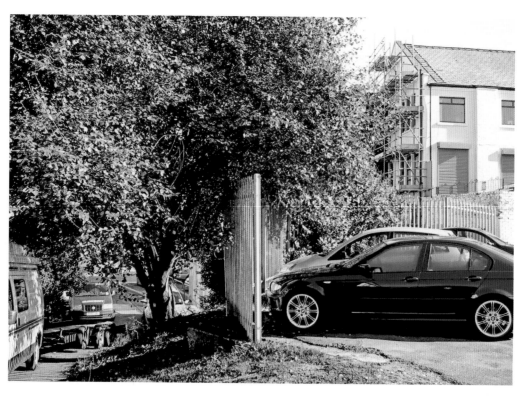

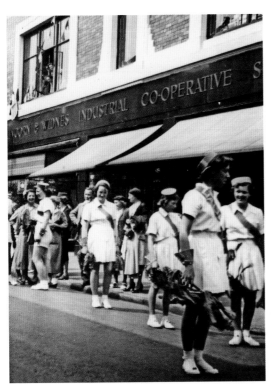

Morris Dancers in Church Street

For many years the United Nations Association organised a carnival through the streets of Runcorn. The colourful processions which included many bands, dancers and tableaux made their way to Runcorn Football Field where the local carnival queen was crowned and festivities began. Here we have one of the many groups of morris dancers pausing outside the Runcorn and Widnes Co-operative drapery store where the cashier sat in her lofty perch, surrounded by a web of wires and pulleys connecting every counter. Money and invoice were placed in a cup and sent flying across the ceiling and quickly returned with the receipt and change. The building has undergone several changes and is now The Ferryboat, a popular Wetherspoons restaurant.

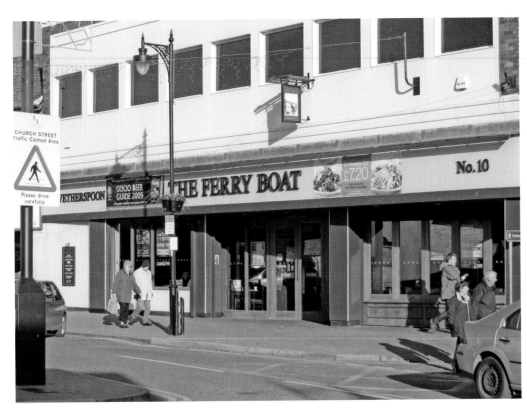

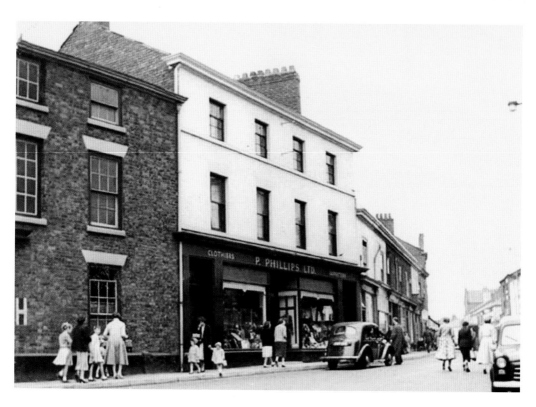

Phillips, Church Street

A busy scene in Church Street in the days when whole families used to saunter along, sometimes in the middle of the road, meeting and chatting to friends. P. Phillips Ltd., Clothiers, Hatters and Hosiery situated at number one, had been established in the nineteenth century. Window shopping was a popular pastime and in the 1950s there were many shops in this main shopping area selling fashionable clothes and shoes as well as numerous butchers, bakers, grocers and greengrocers. Now we have the Halton Direct Link premises on the corner. This building was used temporarily as a market hall.

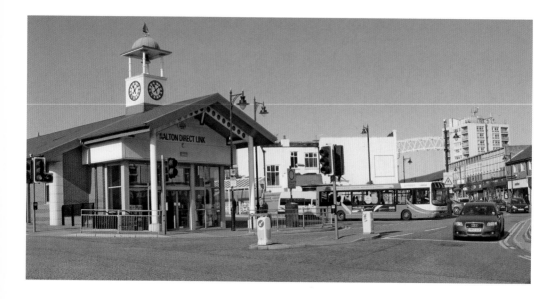

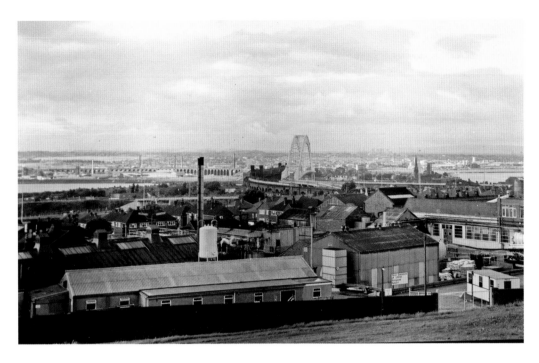

Lescher's, Weston Road

Evans, Sons, Lescher and Webb Biological Institute in Penn Lane began in the early part of the twentieth century. The Institute co-operated with Liverpool University. Research and work was carried on here for over fifty years and was renowned far and wide. Vaccines and antitoxins produced here in Runcorn would have saved many lives throughout the world and the local people who worked there can be justly proud of their achievements. This view from Weston Road shows the new housing estate built on the site.

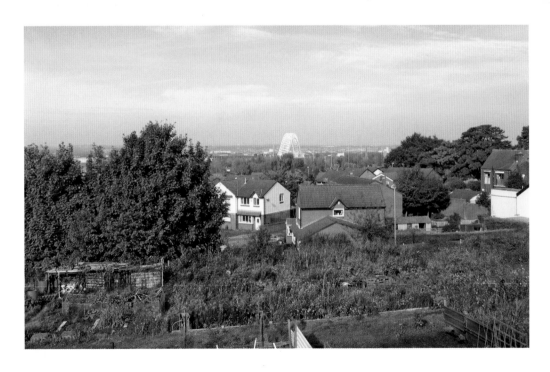

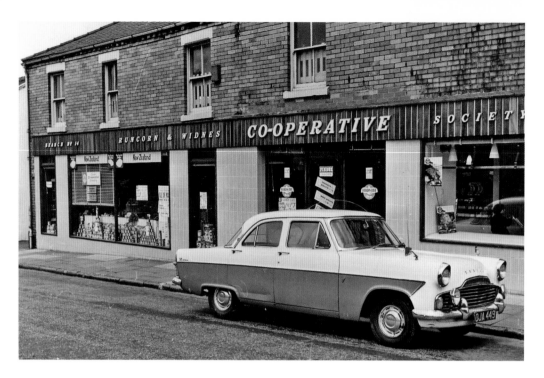

Balfour Street Co-op

The Balfour Street premises of the Runcorn and Widnes Co-operative Society. This was number 14 branch in the days when it was just a small society and was typical of the many shops it owned around the district. This shop has traded here for over a hundred years. In 1902 the first building built was destroyed by a fire, a blessing in disguise, as more space was needed at the time to accommodate a separate butchery department. The adjoining house was taken over to do this. The store has been revamped several times in the last few years and is now part of the huge Co-operative Group after many amalgamations and take-overs.

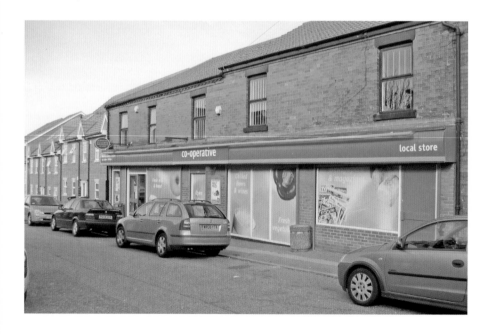

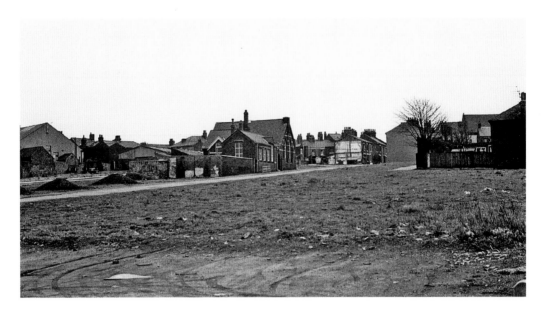

Shaw Street School

Newtown St. Michael's Church of England School, known locally as Shaw Street School, taught the young children of the area for nearly a hundred years. Miss Mack, a lovely lady, was a very popular headmistress at the school for many years. The picture shows the building isolated as most of the nearby houses had been demolished. A local barber, Sid Potts, used the photograph as evidence in his claim for a reduction in his rates as most of his customers had been relocated elsewhere. There is now a car park where the school once stood and the area has been landscaped.

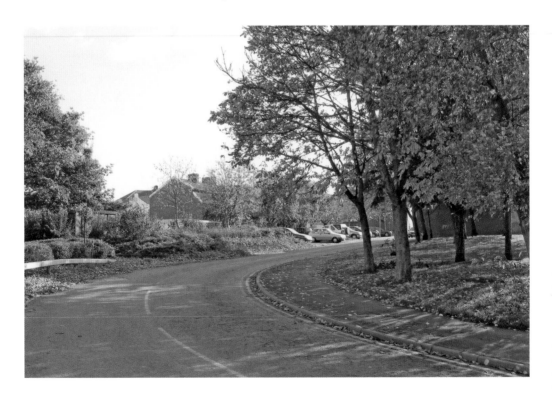

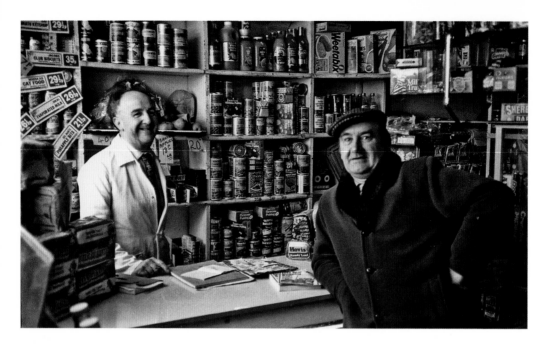

Local Shop

Derek Deakin and a customer, John Lewis, in his small grocery store in Fox Street at the side of St. Michael's Church. There were many such small shops around the town, some of which were just the front parlour of the terraced house, selling a variety of wares. Derek took over this shop in 1953 and soon became a friend to everyone around. Grocery orders were delivered to many homes in the neighbourhood. He moved to these larger premises, round the corner in Greenway Road, in 1984. This had been Townson's Chemists. He, and his wife Kathleen, worked here together until they retired in 2002.

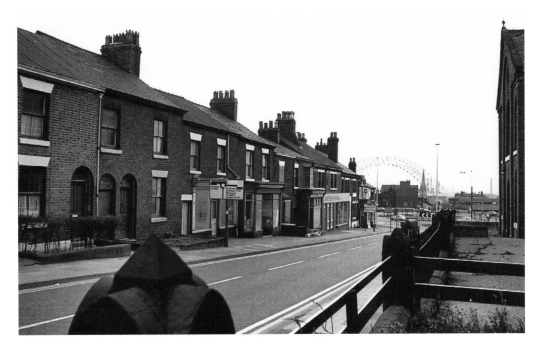

Greenway Road Roundabout

This roundabout was at the bottom of Greenway Road in the 1960s, it was constructed there as part of the redevelopment of roads connecting to the new road bridge. The façade of Greenway Road Methodist Church can just be seen on the right. Several shops, including Rushtons, Clare and Ryder and T. J. Greens, on the left hand side of the road were soon to become victims of the bulldozers. The roundabout was removed when a different layout of roads and subways was required because of the increase in traffic.

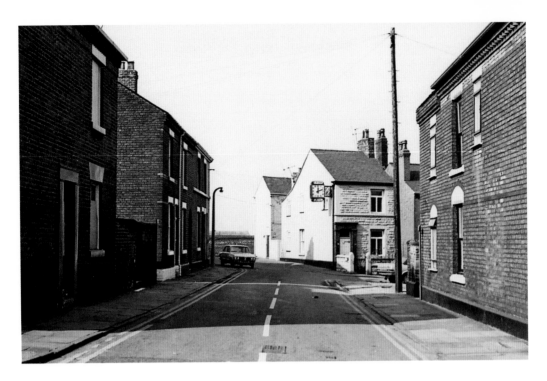

Albert Street

The prominent clock on the corner of Rigbys, Funeral Directors, at the top of Albert Street is remembered by the many people who walked into town down Greenway Road, a quick glance to check the time! The business previously belonged to Fred Durkin, his advertisement read 'My aim and ambition is to keep the Trade Clean and Wholesome, and free from the Degradation of the Tout'. Only a small part of Albert Street is now left which leads to a footpath towards the Railway Station. The street name survives.

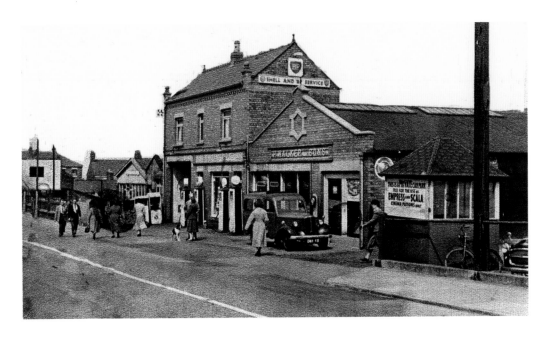

Walker's Garage

Walkers Garage at the bottom of Greenway Road and next to T. Robinson and Sons, the stonemasons. The entrance to the car park (for the use of cinema patrons only!) was on the right. The Walkers, two brothers, Fred and Ernie, moved into these new, larger premises in 1923 from just around the corner, in Chapel Street, where they had built their first garage four years earlier. There would not have been many cars or motor cycles around in the early days. This became a very busy garage and they traded here for nearly forty years. It had a large showroom and a shop with four petrol pumps on the forecourt. Some of the many trees that were planted by the Development Corporation which now mark the spot where the garage once stood have now matured.

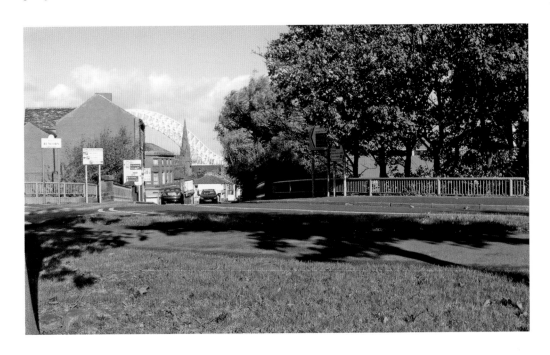

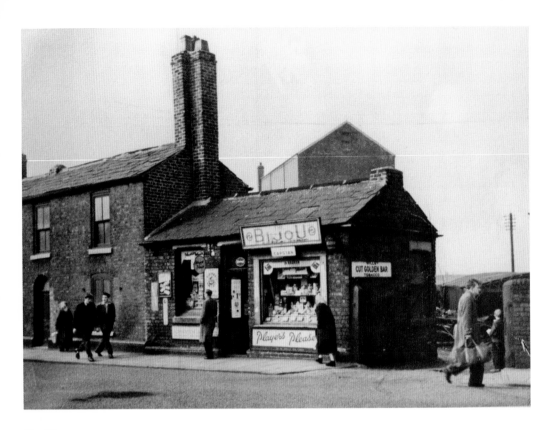

The Bijou

The Bijou, the tiny sweets and tobacconist shop in Lowlands Road. The name was rarely pronounced correctly, it was commonly known as the 'By-joe'. This little shop was a convenient place to purchase goodies on the way to the Empress cinema, or as we would say, the pictures. The good natured queue, on a Saturday night, when a popular film was being shown, could reach and even pass this shop and beyond. The entrance to the Co-op coal yard, which reached down to the canal basin, was on the right. The road here now is the first exit route from the bridge and into town.

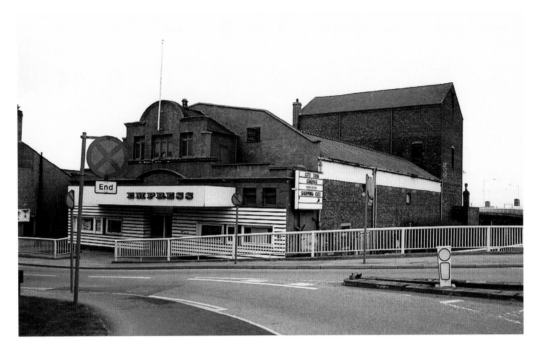

Empress Cinema

The Empress cinema, with its striking 'art-deco' frontage in Lowlands Road. This was a very popular venue for all ages. A full programme, feature film, cartoon, news and the main film were the order of the day. Saturday night was always packed and was a good meeting place for friends. Usherettes, with their torches, would guide the late arrivals to their seats and later bring round the ice-cream. In 1948, at the time of the London Olympics, excited schoolchildren from the local area were taken to the cinema to see film of the athletes performances. How times have changed. It is now difficult to pinpoint the exact site of the cinema but it was somewhere amongst these roads and grassy banks!

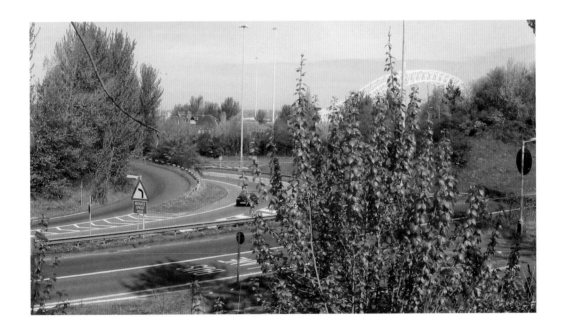

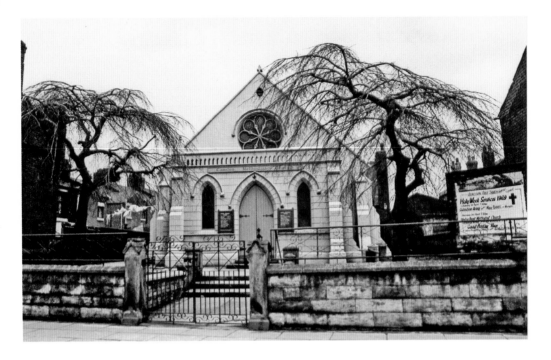

Camden Church

Camden Methodist Church, in Lowlands Road, was built in 1872 by Thomas Hazlehurst, a soap manufacturer. This was the first Wesleyan Chapel to be built in Runcorn. The church closed in 1970 and joined together with Greenway Road, Weston and Laburnam Grove congregations to form The Heath Methodist Church in Vista Road. The Camponile Hotel has now been built on the site, which can be seen beyond the fence, where visitors to Runcorn can stay.

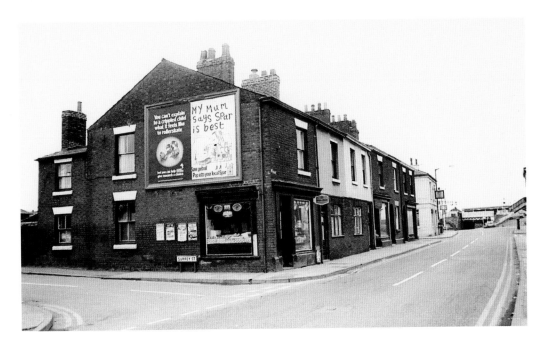

Lowlands Road and Surrey Street

This side of the road was a mixture of houses and shops with a newsagent on the corner of Lowlands Road and Surrey Street. Mr. Gilbert had his sweet shop further along. He was extremely kind to the children who left their sweet coupons with him during rationing. On the far end of this block was Ford's greengrocers with the Railway Hotel across the road, the only building to survive. The road is now just an access road for the hotel and commercial properties.

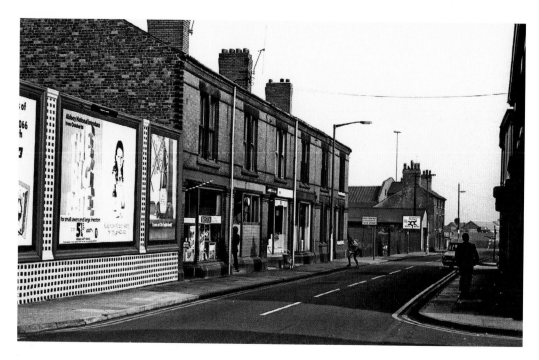

Lowlands Road Shops

Lowlands Road was the main route between the Railway Station and the town centre. Sid Potts, local barber, had his salon in this row of shops. He could do any style as long is was 'short back and sides' . He was never in favour of bank holidays as he always considered them as a day's trade lost! A bookies and a chip shop were also in this row and Runcorn town yard was further along. Picow Electricals now occupy the same site in brand new business premises.

Cavendish Street

Cavendish Street with the children's playground on the left. The building facing at the bottom of the road was the Labour Exchange at a time when jobs were plentiful as Runcorn was surrounded by so much industry. Plenty of opportunities were available to local workers and a change of career was quite easy to achieve. The Lowlands Road branch of the Co-operative society stood alongside. The Railway Hotel has survived and is still serving the community. The piece of land to the right was where a row of terraced houses had once stood. Cavendish Street has now been cut off completely by a busy approach road to the bridge.

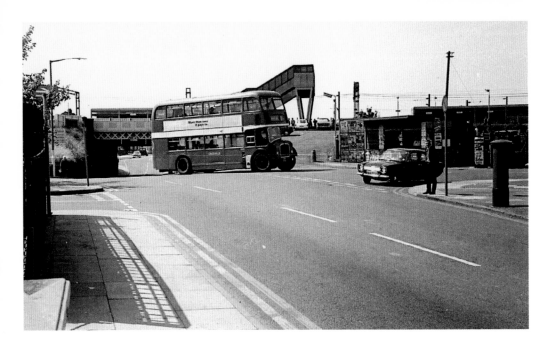

Runcorn Station

The approach to Runcorn Station was on the right up a steep slope. There was a newsagents stall at the bottom, owned by Norman Dukes, supplying daily newspapers and magazines to the many rail travellers. The J9 service operated by Crosville, a regular hourly bus service from Weston Point to Stockham Lane, Halton, can be seen turning into Station Road. Quite a few lorries got stuck under the low bridge, headroom 13ft and also, as it was prone to flooding during heavy rain, many other vehicles came a cropper. A new approach road to the Jubilee Bridge now cuts across the scene.

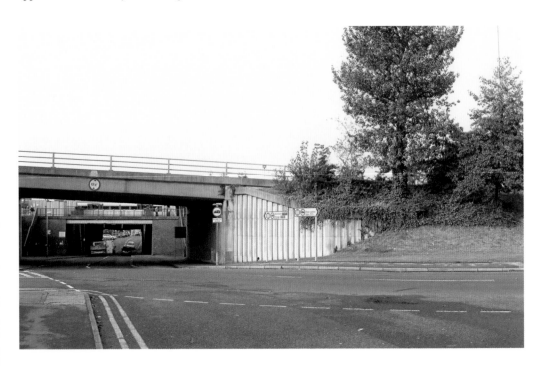

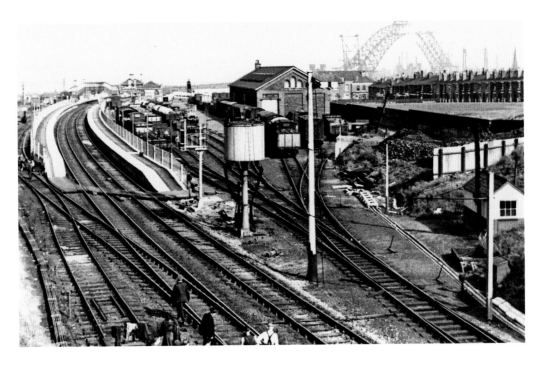

Runcorn Goods Yard

Runcorn Station and Goods Yard about 1960 where work is being done to lengthen the station platforms to accommodate the longer trains for the forthcoming electrification of the lines. The very busy sidings on the right can clearly be seen. Shunting took place far into the night. The boundary wall between the goods yard and Cavendish Street playground was a good vantage point for trainspotters! A fine new footbridge is now in place and the goods yard site is being developed as a multi storey car park. The branch line on the left, which used to serve the docks, is still in use but now terminates in Folley Lane sidings.

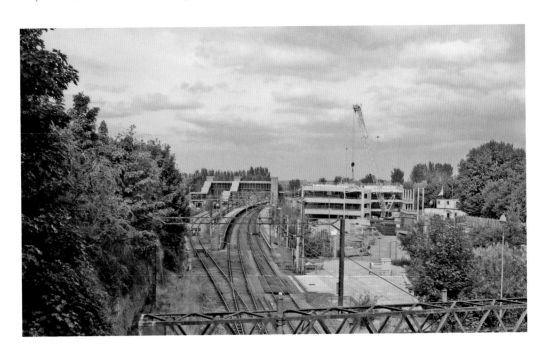

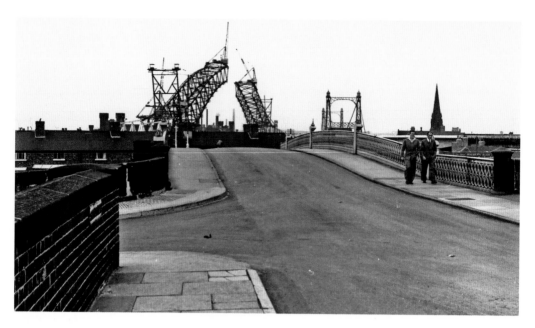

Station Road

Station Road over Waterloo Bridge in the days when the Transporter Bridge was still operating and the span of the new bridge was closing. Access to Percival Lane on the left has now been lost under one of the approach roads leading onto the Jubilee Road Bridge. Percival Lane used to be the very busy route for traffic going down to Runcorn Docks. The cottages, English Row have now gone and spire of All Saints' Church is hidden behind the trees.

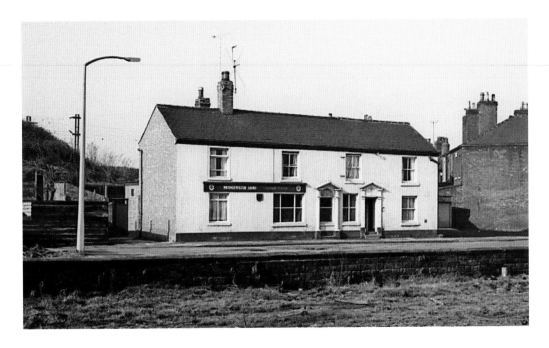

Bridgewater Arms

The Bridgewater Arms was one of a number of public houses in Percival Lane. It was originally named the 'Packet Inn' which was a reference to the many packages of goods that were carried via the canal in the local area. It was renamed 'The Bridgewater Arms' in the early 1820s. Captains from visiting ships often stayed here. There were enough refreshment facilities for eighty two people and it had several bedrooms. In the early 1970s the hotel was converted into apartments. The grassy area seen in front of the building marks the area where both lines of locks crossed.

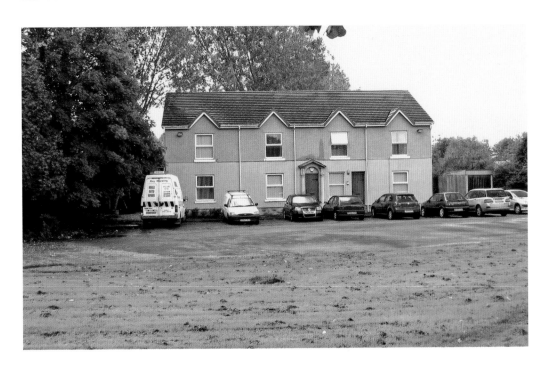

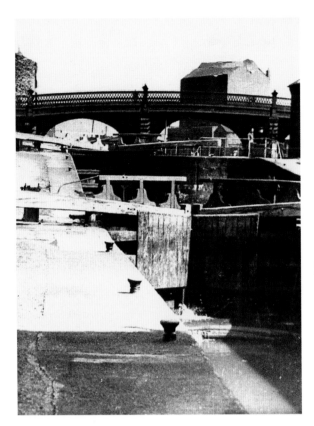

Old Line of Locks

Waterloo Bridge was a welcome sight for boatmen as they arrived at the top of the flight of locks into the Bridgewater Canal with many miles of lock free waterway ahead of them. Access to the Manchester Ship Canal and Runcorn Docks was severed when an approach road to the Jubilee Bridge was constructed and the locks filled in. A pleasant tree lined footpath now follows the line of locks.

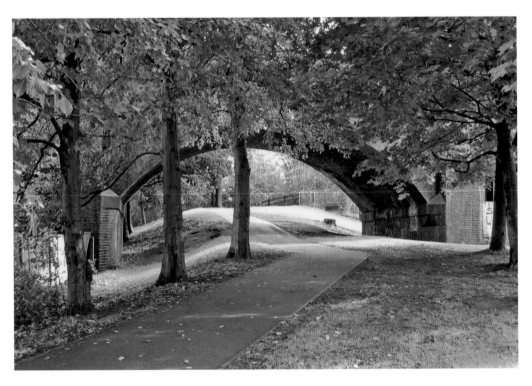

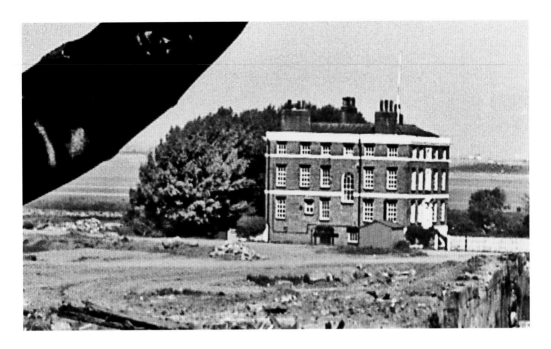

Bridgewater House

This imposing property, Bridgewater House, was built for Francis Egerton, the Duke of Bridgewater, for him to oversee the construction at the Runcorn end of the canal. This fine building no longer stands in splendid isolation. It is now surrounded by modern developments with Halton College on the left and apartments to the right. The old line of locks that enabled the boats to pass between the Bridgewater Canal and the Manchester Ship Canal have been filled in but not destroyed. A group of keen enthusiasts, Runcorn Locks Restoration Society, hope that one day these locks will reopen. A pleasant footpath follows the line of locks and some of the original sandstone on the lock sides can still be seen.

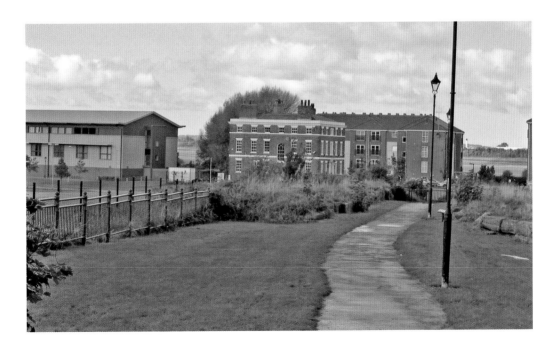

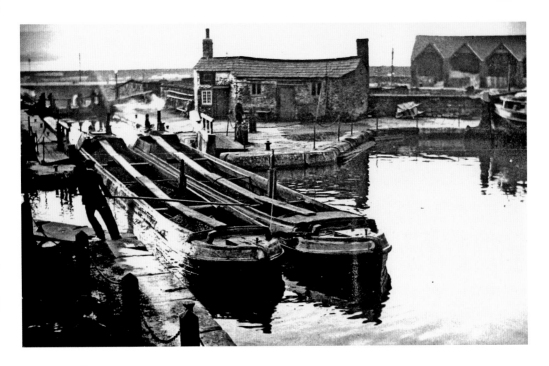

Runcorn Locks

A pair of Horsefields narrow boats starting their ascent from Runcorn Docks, through the ten locks, to the Bridgewater Canal. These boats were loaded with road chippings which had been brought in by ship from Penmaenmawr, on the North Wales coast. The narrow boats would have to be hauled manually through the locks (bowhauled) to the basin at the top where they would then be horse drawn to their destination. The striking new building we have today is The Riverside College, opened in 2002, a great asset to the town with a multitude of courses to choose from.

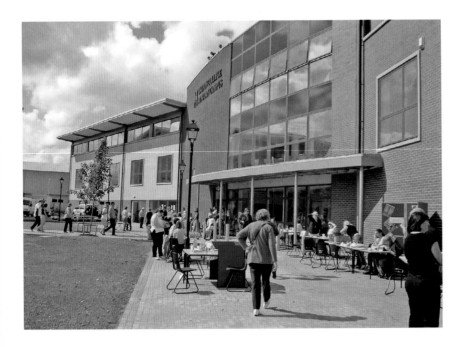

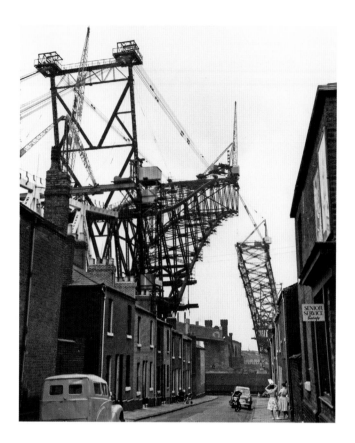

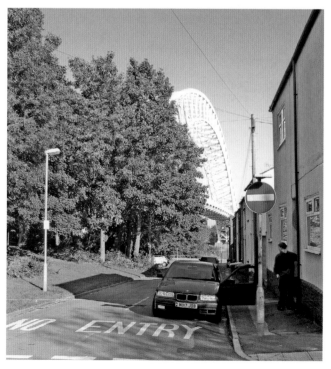

Clarence Street

The residents of Clarence Street look on as the massive structure of the new bridge looms over their homes. The right hand side of the road remains to this day, although the corner shop that is just visible is now a dwelling house. The left hand side of the street was knocked down. It has been landscaped and the mature trees give a pleasant outlook for the houses that are left.

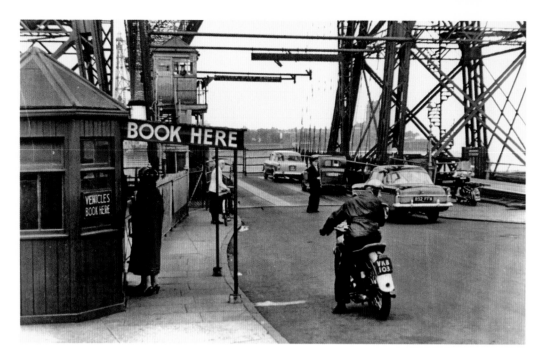

Toll Office

A motor cyclist can be seen waiting to be called by the gateman to board the platform (known as the 'car') on the Transporter, to be carried across to Widnes. Widnes was then part of Lancashire, the river Mersey was the natural boundary between Cheshire and Lancashire. The two towns have now joined to become the Borough of Halton. The long cabin on the left beyond the 'Book Here' sign accommodated foot passengers with the driving cabin above. The landscaped site now has a pleasant viewpoint, looking across to the other side of the river and canal to the tree lined promenade and the prominent tower of St Mary's Church in West Bank.

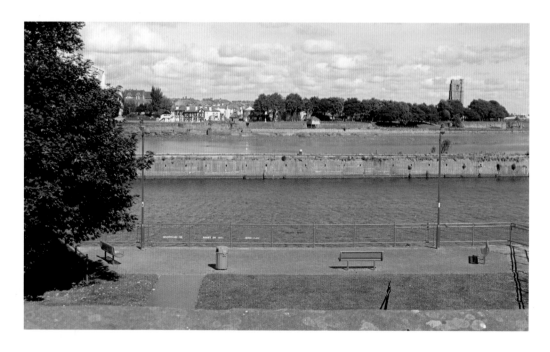

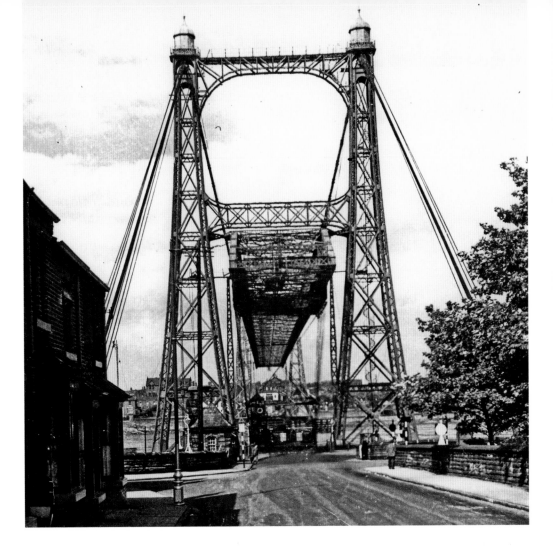

The Transporter Bridge

The elegant towers supporting the 1,000ft span of the Transporter Bridge with the cupolas, the ornamental domes, on the top. The considerable increase in road traffic in the 1950s, also the age of the structure, meant that the construction of a road bridge was a necessity. This new bridge was opened on the 21st July 1961 and our beloved Transporter, after serving the town well for 56 years, was closed the day after. It was soon demolished and all that now remains is a commemorative plaque on the Widnes side.

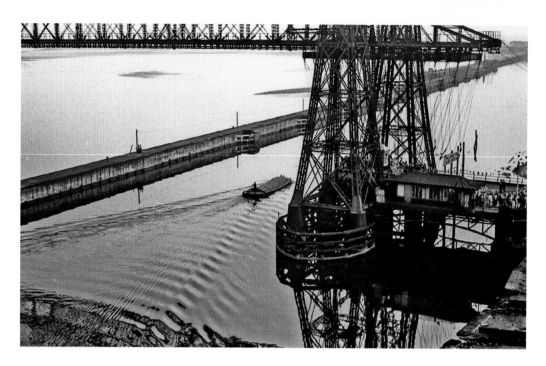

Last day of the Transporter

The last day of operation for The Old Transporter Bridge, 22nd July, 1961. Bedecked with flags and bunting it carried its last passengers and cars. The sound it generated as it swung across the Manchester Ship Canal, over the gantry wall and the River Mersey, was quite unique. It had a timetable but on busy occasions it ran what was locally known as 'quick cars' to relieve the queues of vehicles in Waterloo Road. In strong winds, the whole operation had to come to a halt and a walk over the footpath on the railway bridge was the only way to get between Runcorn and Widnes for pedestrians. Vehicles had to travel via Warrington to get to the other side of the river. A walk along the new pathway, on a fine day, is very enjoyable.

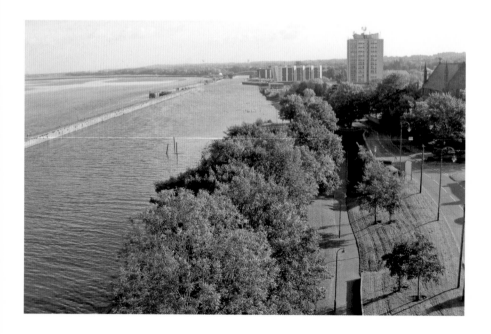

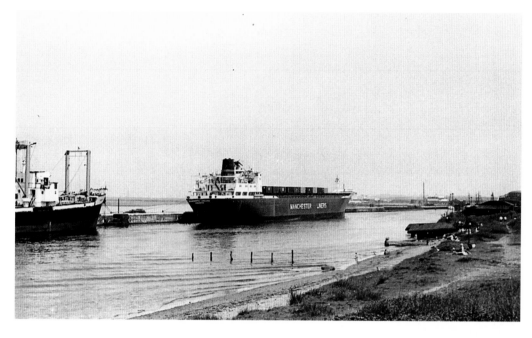

Manchester Liners

The Manchester Ship Canal in the days when it was an extremely busy waterway, with ships from all over the world, carrying a wide variety of goods to docks all the way to Manchester. The ships, pictured here, were moored on the gantry wall, dividing the canal from the river, awaiting a passage and berths at the docks. The banks of the canal became our local seaside and picnic area, 'Ferry Hut', the site of the original ferry across the river immortalised in the monologue 'Tuppence per person per Trip'. Nowadays, very few ships pass this way but the area has been tastefully landscaped with excellent views and seating.

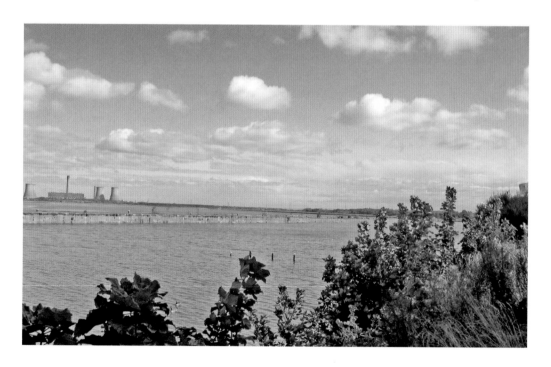

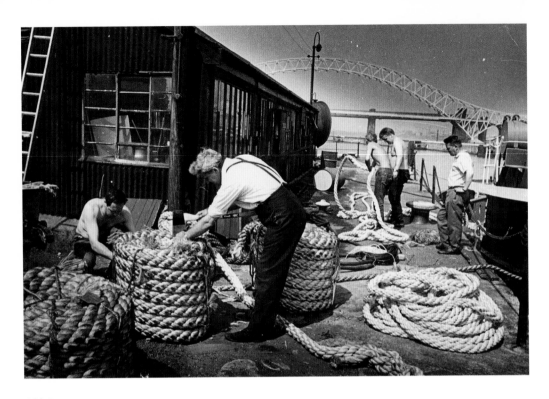

Old Quay

A busy scene in the Old Quay Yard where the tugs, which guided the ocean going vessels through the Manchester Ship Canal, were maintained. Many men worked in the yard preparing the ropes for towing and fender making. This yard was also responsible for the repair and maintenance of lock gates on the canal. The new block of apartments that have now been built on the site have lovely views over the river and canal. Visitors can now walk along a path which was once the quayside.

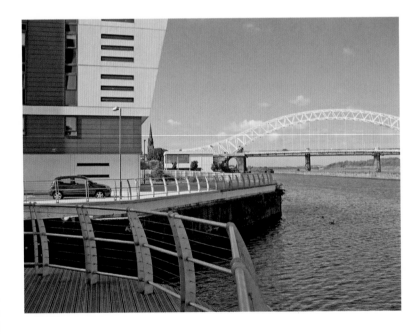

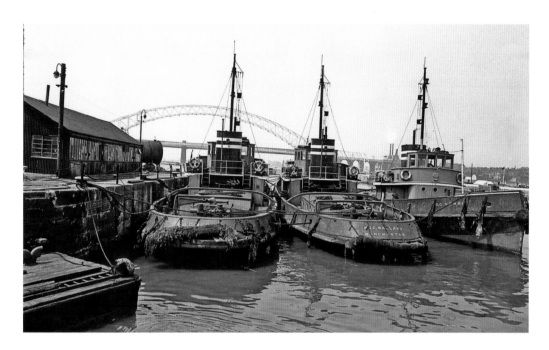

Tugs at Rest

Three tugs, *Merlin*, *Mallard* and *Nymph*. Awaiting orders for their next duty at the Old Quay Yard. The tugs played an important role in the movement of ships on the canal. In the 1950s and early 1960s as many as twenty six vessels were engaged in this work between Eastham Locks, the entrance to the River Mersey, and Manchester Docks. The crews worked 24 hours on duty and 48 hours off. The new quayside apartments are called 'The Decks' and were designed to resemble the decks of a ship and some now overlook where the tugs were berthed with the two bridges in the distance.

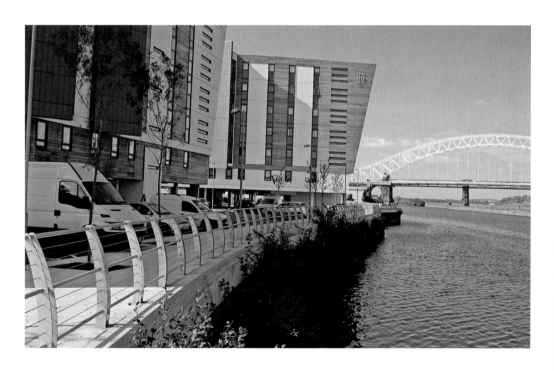

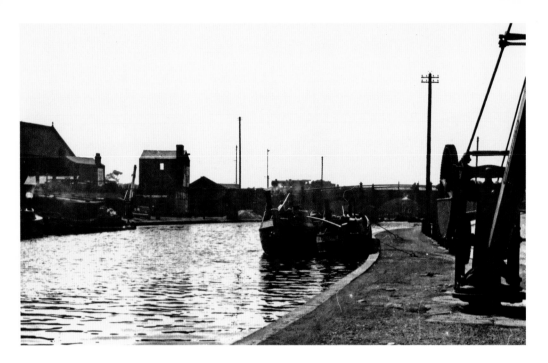

Top Locks Basin

A pair of narrow boats moored for the night in Top Locks Basin about 1950. Traffic on the canal was in rapid decline at this time with more and more cargoes being transported by road and rail. A freight train can be seen in the picture crossing the viaduct approaching Runcorn Station. The crane, standing idle, on the right has been replaced by trees and on the other side of the canal, pleasure craft rest in the sunlight at their moorings.

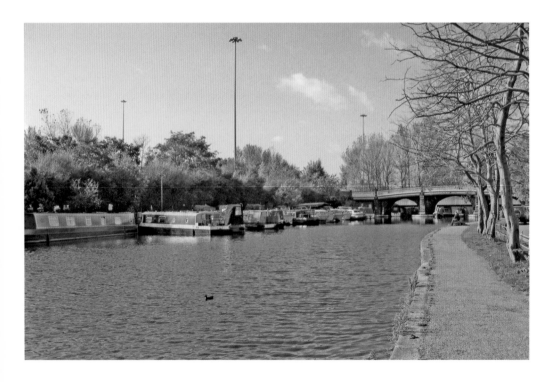

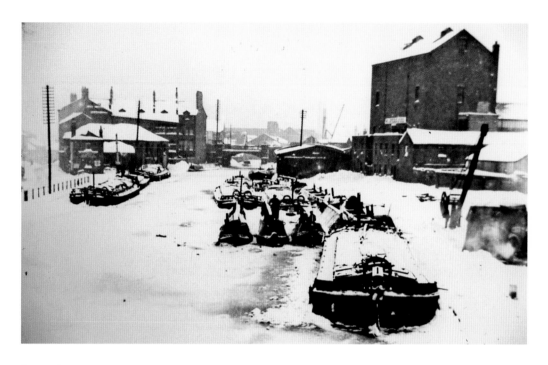

Frozen In

Barges and narrow boats, frozen at a standstill, in the basin in 1936 between Doctor's Bridge and Waterloo Bridge. The people who lived on the boats would bave experienced very hard times when they were unable to continue on their journey but the cabins would, or should, have been cosy and warm. The large building on the right was the Empress cinema with the Co-op coal yard to the left. Coal from the mines in South Lancashire was brought here to the yard in narrow boats. The canal is now mostly used for leisure and the present day picture shows some craft, at their moorings in the springtime.

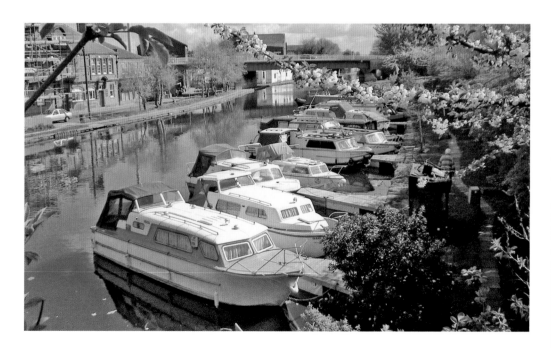

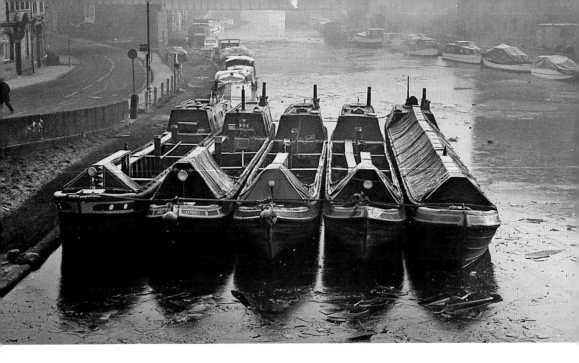

Working Boats

A cold and frosty morning in February 1968. Five narrow boats of the Anderton Canal Carrying Company were moored, side by side, in the icy waters of the Top Locks basin on the Bridgewater Canal. This company was founded in December, 1967 by Alan Galley after the Willow Wren Company had closed down. Times became difficult with too few cargoes available so unfortunately the company ceased trading in 1972. The boats sailed to Runcorn on many Saturday mornings for the families who lived on board to do shopping, visit the cinema and enjoy a night out at the local hostelry. They returned to their base at Preston Brook the following morning. The narrow boats have now been replaced in the basin by smart looking pleasure craft. The owners of these new boats have formed themselves into a friendly community.

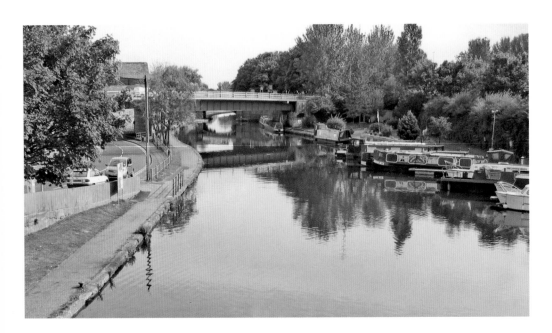

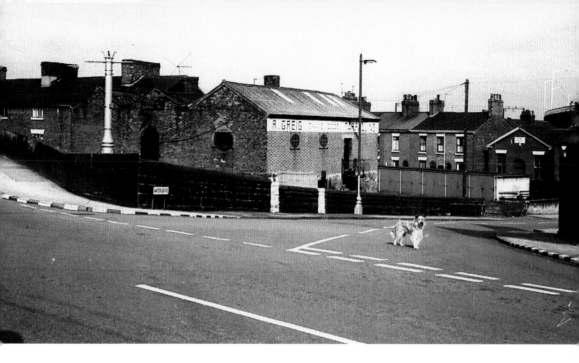

Greig's

R. Greig traded here for many years, in the loft above the stables, at the top of Waterloo Road from the 1920s. They did all kinds of canvas work. They made sails, barge covers, tarpaulins, cart covers, sun blinds and even motor hoods. The company are still in business, they trade from premises in Irwell Lane, in the old Mariners Mission. In the past, the horses used for towing the narrow boats were stabled here. Mithane gas was used to illuminate the stylish lamp that still stands on this corner, but now not lit, where the public toilets used to be. A pedestrian subway, under the road, leads to the former Welsh Chapel and the lower part of waterloo Road.

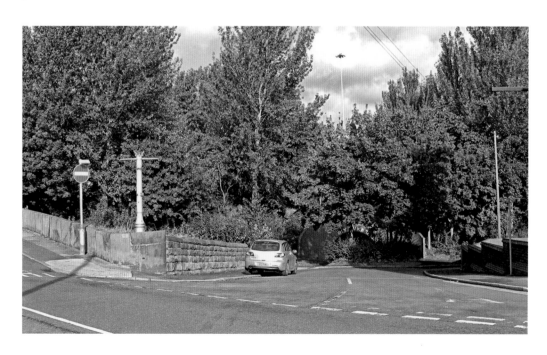

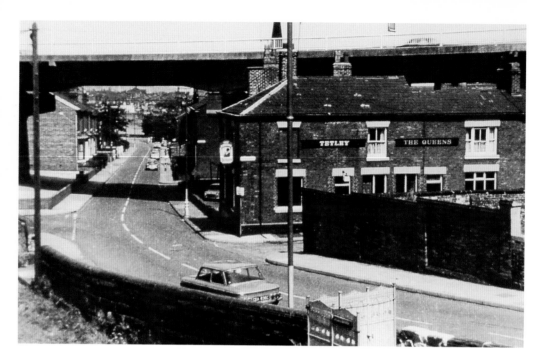

The Queens

Waterloo road was the main route to and from the Transporter Bridge. The Queens public house stood on the corner of Duke Street and Waterloo Road until it was closed and demolished to make way for the new road, the Runcorn Busway. When this new road was first opened it was only for buses only but it is now open to all traffic. The red brick wall on the far side of the road marks the boundary of the Waterloo Hotel car park.

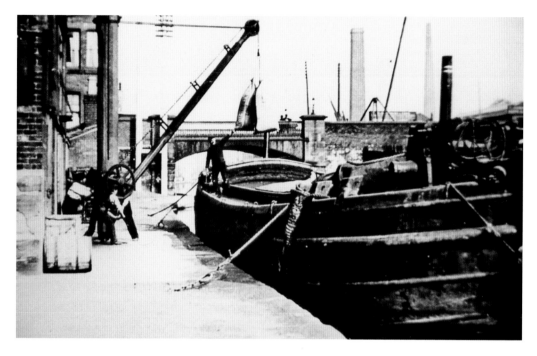

Town Warehouse

This picture shows a busy scene at the Town Warehouse, below Doctor's Bridge, as a barge was being unloaded with goods for local businesses. Many traders in the town received and sent their wares from here. The cranes have gone and the building, which was used as a garage and workshop for many years, now stands empty and forlorn awaiting its fate.

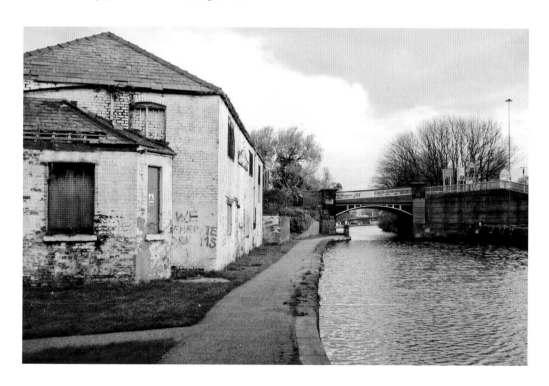

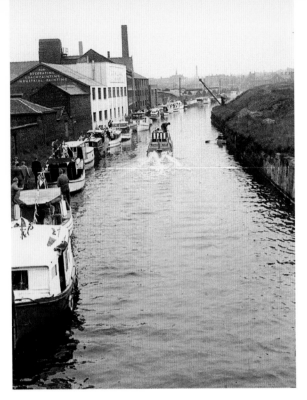

Boats from Doctor's Bridge
This was an early boat rally, seen from Doctor's Bridge, in the early 1950s. All the buildings on the left originally belonged to Camden Tannery. The white building was taken over by E. D. Williams, Painters and Decorators. They also had retail premises on the other side which was in High street. The land on the right hand side of the canal was occupied by Runcorn Soap and Alkali Co. Ltd. in the nineteenth century. Only a small section of the tannery wall now remains dividing what is now a car park from the canal tow path.

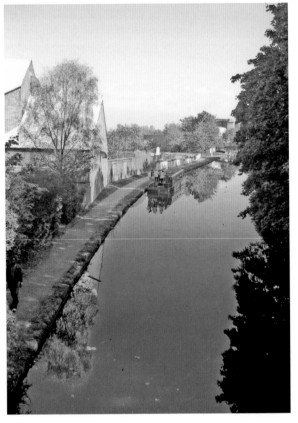

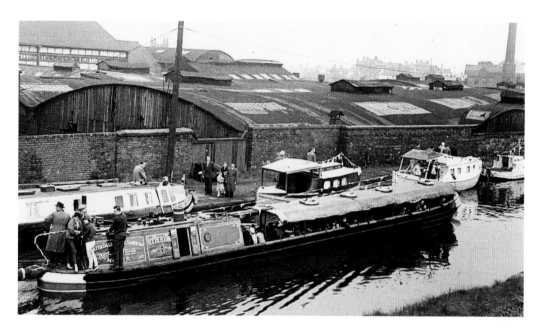

Camden Sheds

The sheds of Camden Tannery dominated these banks of the Bridgewater Canal. The occasion was a boat rally. Three of the small boats in the picture originated from old ships' lifeboats which had been converted. These were typical pleasure craft of the time. Now we have 'The Brindley' a wonderful theatre and arts centre, named after James Brindley, engineer on the Bridgewater Canal. It was opened in 2004 by two stars of Coronation Street. The centre has been a great success with various shows, art exhibitions, classes and workshops. It won the National Lottery award for the Best Arts project in the UK in 2007 and followed that with Best Performance Venue 2008, awarded by the Mersey Partnership Tourism Awards.

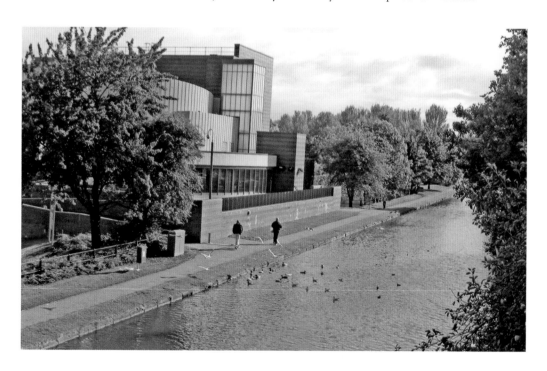

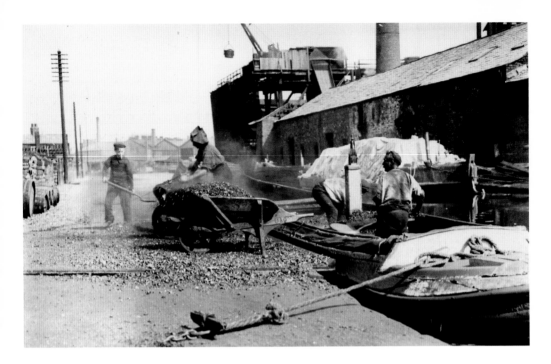

Unloading Coal

What a difference the years make. The Bridgewater Canal, at the back of Camden Tannery, where coal was unloaded from the narrow boats for use in the tannery. It was a dirty and arduous task. This was the way that the coal was brought to Runcorn for use in this industrial town. After the boats had sailed away, poor people would dredge the spot where the coal had been unloaded with a bucket on the end of a rope to glean any coal that had been spilt for use in their own fireplaces. Today, pleasure craft have replaced the working boats and local walkers and fishermen enjoy the area with its well maintained towpath – a more relaxed place altogether.

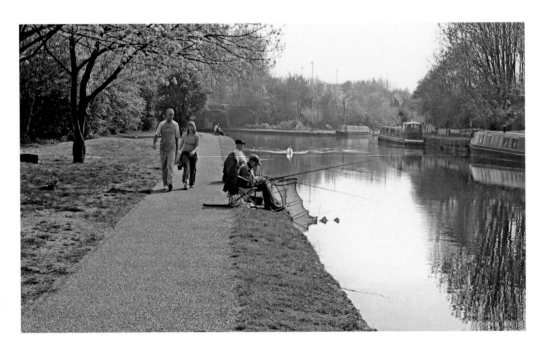

The Boat Club

The large, sad looking, derelict site of the Sprinch Yard, on an arm of the Bridgewater Canal was given this marvellous transformation by the Runcorn Boat Club, the envy of many other boat clubs around. The beautiful clubhouse, with well kept gardens, hosts many social gatherings and meetings. The surrounding area, complete with its own dry-dock, has safe berths for the members' boats. The change has been quite remarkable.

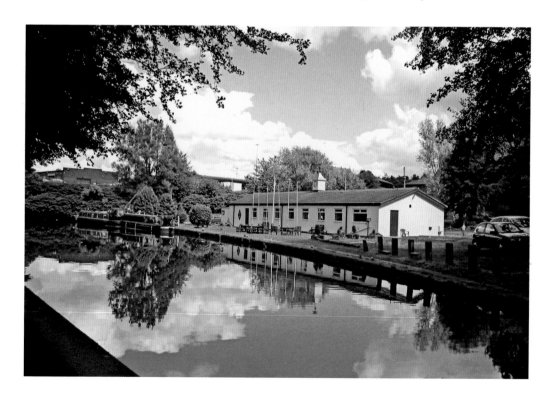

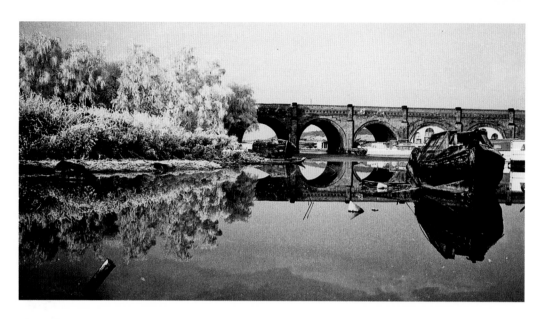

Big Pool

A very frosty morning at the end of an arm of the Bridgewater Canal, commonly known as 'Big Pool', with abandoned narrow boats. This became a graveyard for disused craft when canal carrying was in decline. When the canal was completely frozen over during a severe winter in the 1940s, parts of the old wooden boats which were above the surface of the ice were hacked off to be used as fuel for the fires in local homes. The bridge formed part of Victoria Road, now divided, with only a pedestrian subway connecting each end. We now have a landscaped area with a small pool.

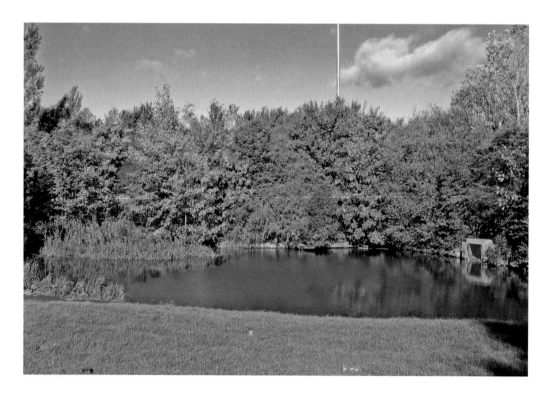

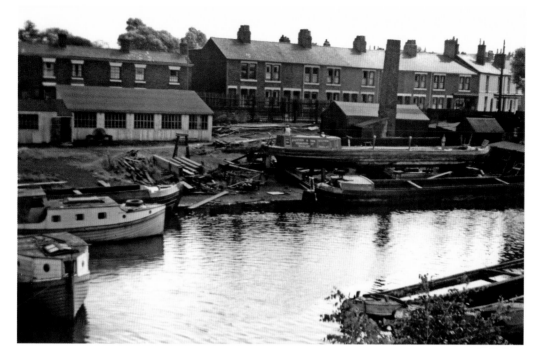

Simpson Davies

Simpson Davies was a busy boatyard in Heath Road. They were responsible for the building and repairing of numerous narrow boats for various Runcorn carrying companies. They owned a large fleet of boats themselves. In this picture, taken in 1958, there is a boat on the slipway for survey. This boat, named *Silver Jubilee*, belonged to Potters of Runcorn and Hanley before it was sold to a carrier in the Midlands. Pleasure craft were starting to make an appearance on the canal. The public house, the Union Vaults, now the Union Tavern is the only feature remaining, the boatyard is buried underneath the Expressway.

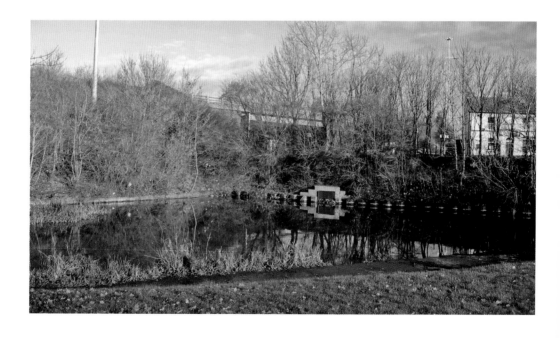

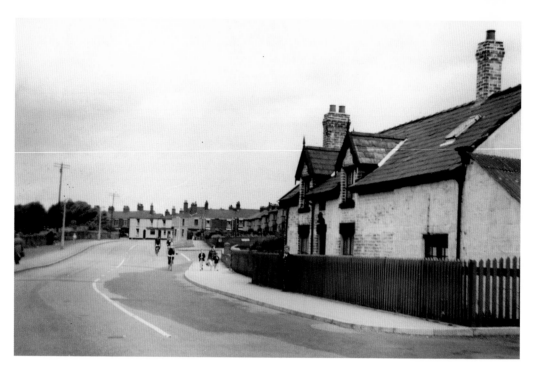

Crowther's Farm

Crowther's farm in Heath Road was one of several farms in the Runcorn area. This was very much a working farm with livestock and crops. Many youngsters who lived nearby found useful employment here during the long summer holidays, doing farmyard tasks or maybe potato picking. During the second world war, housewives and children from the neighbourhood formed queues at the back door to buy any produce that was available. Outside, at the front of the farmhouse, large bins collected waste food to be used to feed the pigs. The bridge support for the Spur Road now sits on the site of this farm with the public house still in the distance.

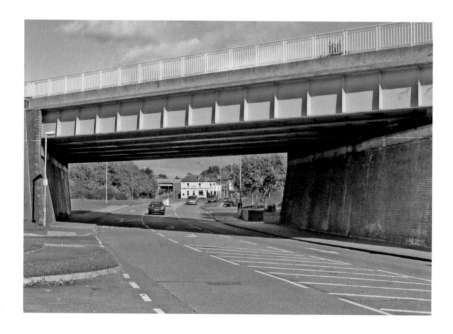

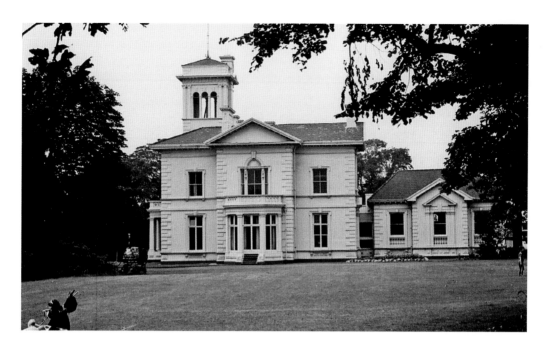

Town Hall

This distinctive property, Halton Grange, was built in 1856 for Thomas Johnson, a local soap and alkali manufacturer and changed hands several times until it was purchased by the Runcorn Urban District Council in 1932, for use as the Town Hall, for the princely sum of £2,250. The local newspapers at the time accused the council of 'squandermania'. in 1963 plans were put forward to demolish this building, one of the finest in the district, and replace it with a modern construction. Thank goodness this did not happen! Halton Borough Council must be complemented for the excellent restoration and refurbishment to the house and grounds. A new path and security railings have now been added.

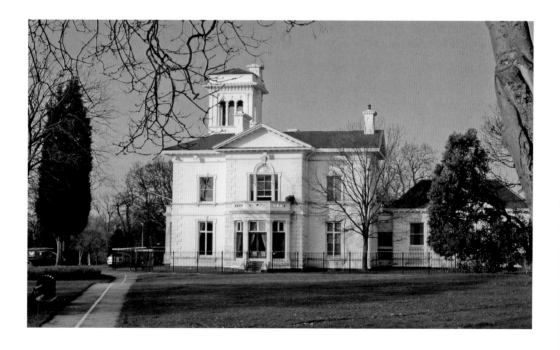

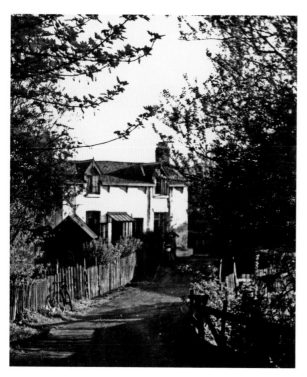

Pool Hollow

Pool Hollow is in Heath Road opposite the Town Hall grounds. Access to the several small cottages, with well kept gardens, was down a narrow tree lined path over a stream. The stream is still rippling its way through but the cottages have long since disappeared and have been replaced by fine new houses with a much improved access lane enabling the residents to drive their cars right up to their homes.

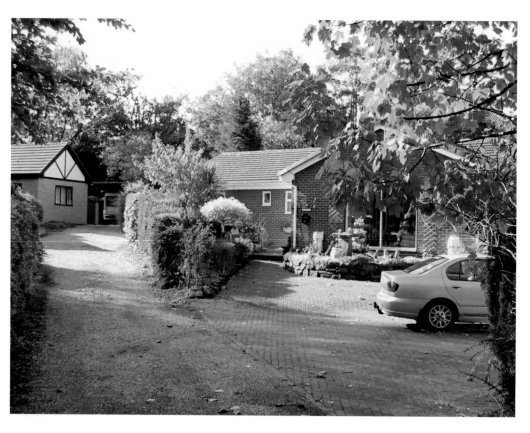

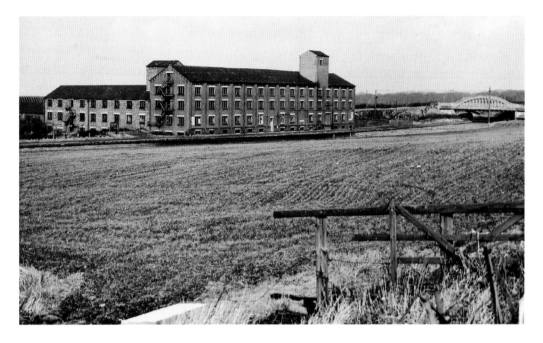

Astmoor Tannery

This enormous building, Astmoor Tannery, on the banks of the Bridgewater Canal was one of several tanneries in the area, the others being Camden, Highfield and Puritan. Most of the materials used in the industry were brought in by boat. The huge demand for leather ensured employment for many years for local men and women. Highfield was one of the largest tanners of upholstery hides in Western Europe, whereas Puritan was renowned for shoe leather. The demise of the tanneries came very quickly in the mid 1950s, when cheap, man-made substitutes, which never really reached the quality of the 'real thing', became available. By the late 1960s all four tanneries had closed.

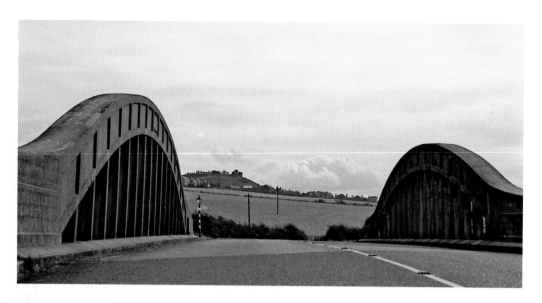

Astmoor Road Bridge

The Astmoor Road bridge was part of the main route between Warrington and Runcorn. This concrete structure carried the traffic over the Bridgewater Canal and was taken down in 2000 to be replaced by the Daresbury Expressway. The turning to the left was Astmoor Lane. This lane was a route up to Halton village, where the remains of the castle stand proudly on top of the hill. The castle dates back to the Norman invasion of Britain and was built after the county had been granted to Hugh Lupus by William the Conqueror, it was badly damaged during the English Civil war and left to ruin. The castle is now hidden from view by trees but a small part of the bridge approach has been retained and can be used for parking and as a viewing point.

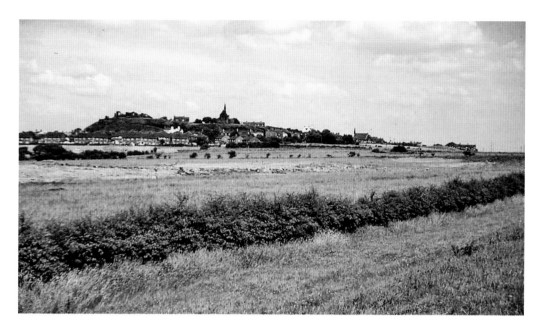

View from the Calvers

A view of Halton village, a landmark for miles around, with the Castle and St. Marys Church. The prominent spire of Trinity Methodist Church is on the right. Halton was only a small village before it was surrounded by property built by the New Town Development. The agricultural landscape has now gone forever. The ruins of the castle can just be seen, in the centre of the present day picture, above the trees. This is now the 'Calvers' estate.

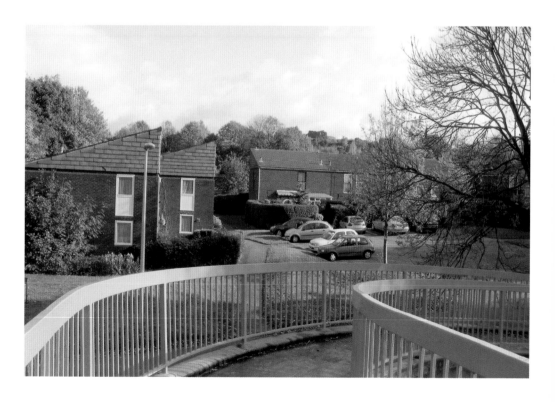

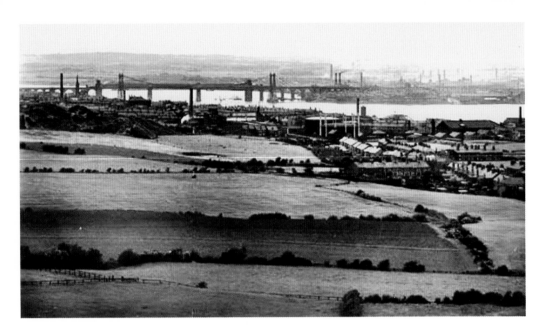

Runcorn from Halton Castle

A view of Runcorn from Halton Castle with open fields, the Railway Bridge and the Transporter Bridge crossing the 'Runcorn Gap' in the distance. The Gas Works, in Halton Road are in the centre of the picture. After the second world war, new housing estates blossomed on the outskirts of the town, they gave better living accommodation for the people who had occupied some of the older properties. The graceful span of the new Jubilee Bridge has now taken the place of the Transporter and bright new houses nestle among the forest of trees. The Anglican Cathedral of Liverpool can be seen on the horizon.

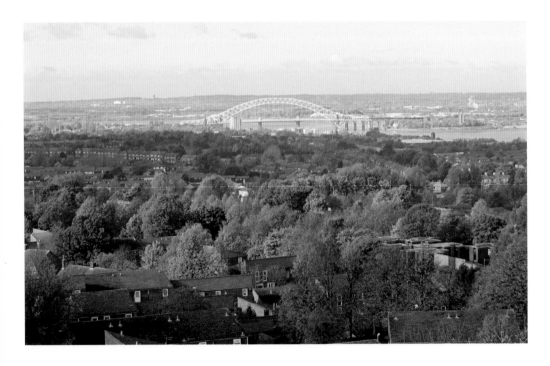

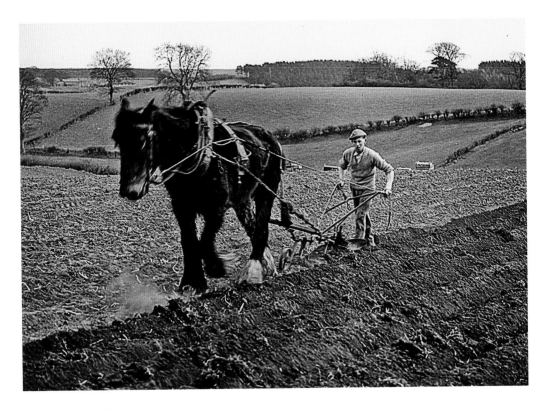

Ploughing the fields

This horse pulling a plough was a familiar sight on the outskirts of Runcorn. It was then a much slower pace of life which has long since gone. There were numerous farms surrounding the town which were taken over by the 'New Town Development'. Dramatic changes have taken place over several years. Roads have been constructed and many properties built.

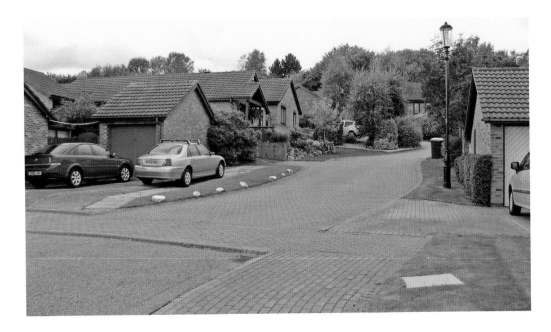

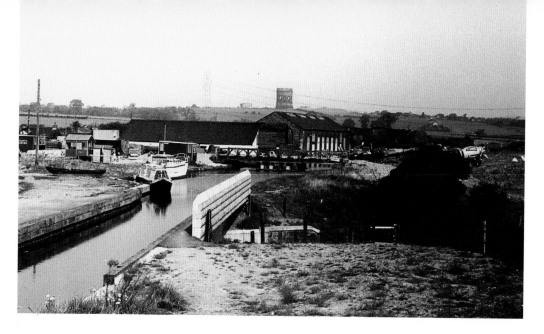

View from Preston Brook

The Bridgewater Canal at Preston Brook. This was once a busy transhipment point for cargoes being transferred from the wide Bridgewater barges to narrow boats for further carriage down the narrow canals to the Midlands and beyond. A large marina for leisure craft is now situated behind the trees. Opposite, are the attractive buildings of the Marina Village where the warehouses and basins once were. Norton Water Tower can still be seen in the background. A small aqueduct carries the canal over the West Coast main railway line.

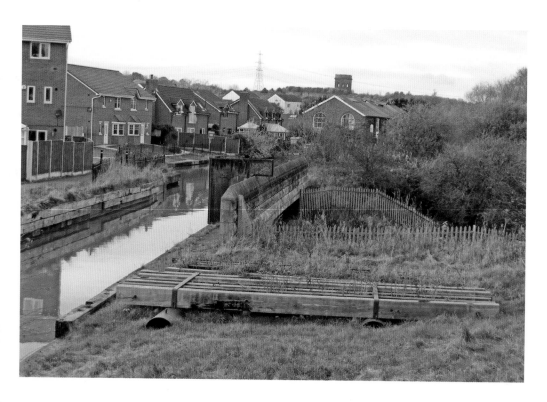

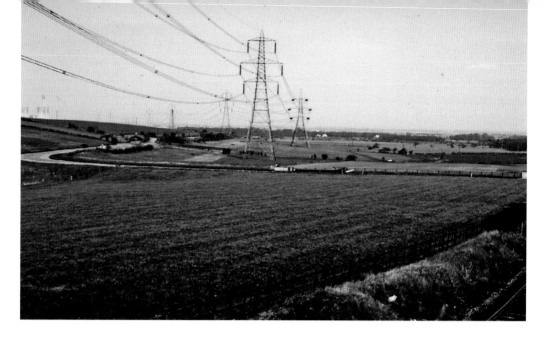

View across Norton

The Cheshire landscape, from the bridge over Norton Station, as it used to look. The Bridgewater Canal winding its way through the countryside with a pair of narrow boats , belonging to the Anderton Company, sailing along in the summer of 1969. Norton Station closed and a site about a hundred yards further along the track became the brand new 'Runcorn East'. This line runs from Manchester to the North Wales coast. A new housing estate of desirable homes now covers the fields and many trees were planted that have now matured well. The same electricity pylons and cables still span majestically across the land.

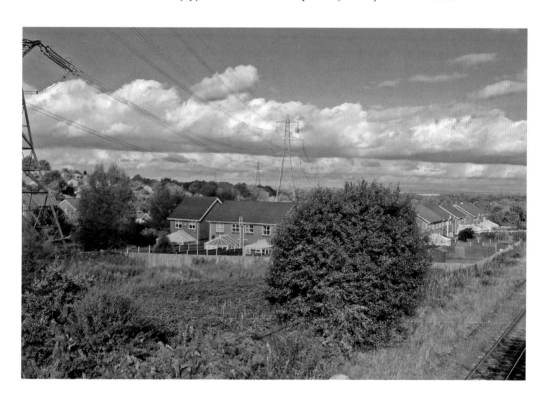

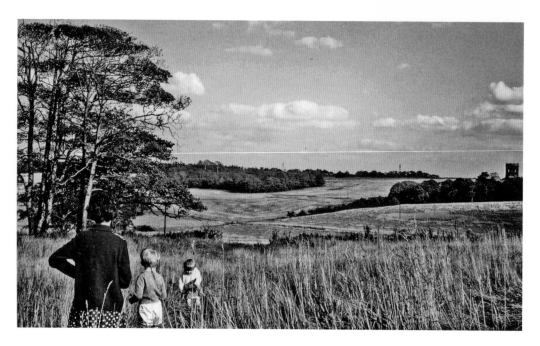

View behind Summer Lane

A picture of a mother and her two children looking across the fields with Norton Water Tower in the distance. These fields, at the back of Summer Lane, in Halton village, were once part of the grounds of Norton Priory. There is now a Norton Priory Museum. In the 1960s and 1970s a new estate, Castlefields, was built consisting of affordable houses and flats. Many of the blocks of flats that were built then have now been demolished and new, better, properties have taken their place.

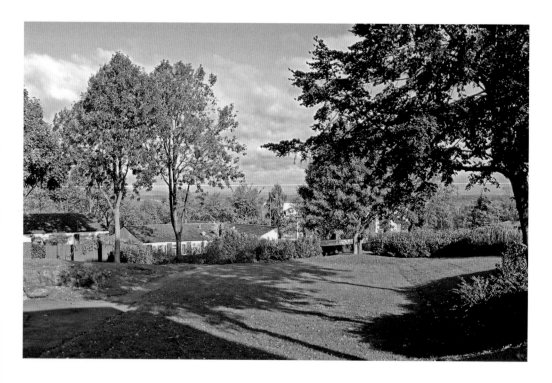

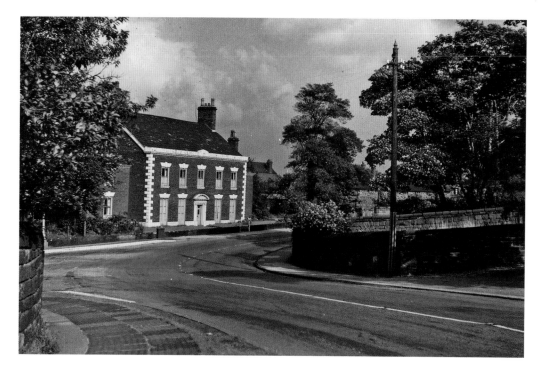

The Elms

......and finally, this elegant Georgian building 'The Elms' in Weston Road. It is a late eighteenth century townhouse and one of the oldest properties in Runcorn. The town has altered so much over the last fifty years or so that it is extremely comforting to see that this fine dwelling still looks the same. It is, of course, a listed building. A local farmer, Alec Grice, lived in this property for many years. The interior has now been tastefully converted into flats with a small cottage at each end. A house that was built to be lived in and still is.

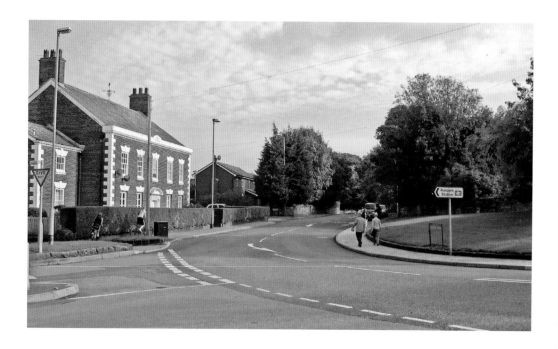

Acknowledgements

The top of the list must be my wife Joan and my grandson Jonathan, without whom this book would have been a non-starter.

I would also like to thank Liz & Brian Howard of the Curiosity Bookshop Runcorn for their encouragement and advice.

Finally, thanks go to the following people for their photographs, information and help:
Pam Pitt, daughter of the late Peter Smith
Linda Finnigan
Percy Dunbavand
Ray Miller
Bert Starkey
Peter Coleman
Frank Walker
Maurice Littlemore
Derek Deakin
Sybil Mitchell
John Rutter
Alex Cowan
Barry Moorefield
Richard Monks
Frank Hall
Gill & Russell Beavon
Trevor Carr

Apologies to anyone who I may have missed.